COMPLETE
DIGITAL
Photography

COMPLETE
DIGITAL
Photography

Tom Ang

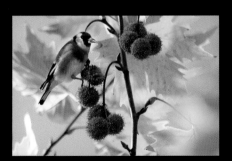 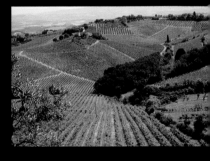

This book is dedicated to my former students

This edition published by Connaught
an imprint of New Holland Publishers (UK) Ltd
London ▪ Cape Town ▪ Sydney ▪ Auckland

Garfield House, 86–88 Edgware Road
London W2 2EA
United Kingdom
www.newhollandpublishers.com

ISBN-13: 978 1 84517 109 4
ISBN-10: 1 84517 109 8

Publishing managers Claudia dos Santos & Simon Pooley
Commissioning editor Alfred LeMaitre
Editor Anna Tanneberger
Designer Nathalie Scott
Concept design Geraldine Cupido
Proofreader Leizel Brown
Production Myrna Collins

Reproduction by Unifoto Pty Ltd, Cape Town
Printed and bound in Singapore by Tien Wah Press (Pte) Ltd

contents

INTRODUCING
digital images

Digital images everywhere

Digital images are at work everywhere you look in the modern world – and even where you don't look. Every picture you see in a newspaper or magazine will have been through a digital process. Of course, every one of the hundreds of millions of images on the World Wide Web is digital in nature. Search the web for 'photograph' and you will be offered at least 6 million pages; the word 'photo' produces a staggering 107 million pages. Less in the front line, digital imaging is behind modern technologies from satellite surveillance to weather forecasting and speed cameras. Even television or video images are essentially digital; each frame making up the moving image is itself a digital photograph. In short, you cannot get out of bed in modern society without encountering a digital image. Some studies have shown that a typical urban dweller sees, or is presented with, an average of 2500 images every day – from television and advertising posters to postcards and packaging.

Digital for you

Digital imaging is no longer something done by technology enthusiasts or dedicated amateurs. The number of digital cameras in use worldwide now exceeds 250 million and nearly every new cell phone (mobile) can take pictures. Photography itself has been so stimulated by new digital cameras that amateurs who used to shoot perhaps a few dozen pictures a year, now admit to shooting hundreds on just one holiday.

If you own any electronic equipment, the chances are that it slots somewhere into digital imaging. Your new cell phone almost certainly takes pictures, and maybe even video. Your personal data assistant probably accepts a digital camera attachment. Your MP3 music player can store images. Your printer may print direct from a digital camera. And, of course, your computer can store, process and help transmit your images.

It is important to accept that digital imaging has reached maturity. Obtaining the quality now offered by dozens of consumer-priced cameras would once have cost you as much as a family car! So it is safe to advise you not to hold back. If you want to try out digital image-making, go out now and purchase a camera. You can be sure to find an affordable camera that provides the quality you need.

Relating to digital imaging

Digital images are rather like the wind. You know there's a wind blowing because of the effect it has on the sand, trees and your skin. You only know there's a digital image around because of the effect it has on a computer screen, cell phone (mobile) display, printer or piece of paper. This is because you cannot see a digital image itself, only its form when it is expressed or 'output'.

As a result, the biggest problem for beginners is how to cope when things go wrong: you can't see that a screw is loose or a linkage broken. However, modern equipment is extremely reliable. Their complexity is such that if one thing failed, nothing at all would work. Therefore, if your equipment works, but you cannot get results, then all you have to do is follow the instructions. The key is to realize that errors occur almost always because you did something incorrectly. This is actually good news because it means that the problem is something you can correct: no need to send the kit back or return to the shop.

Tips and hints

- Read only two to four pages of the instruction manual at a time: more than that is pretty indigestible.
- If anything goes wrong or not to plan, don't panic. Retrace your steps and follow the instructions.
- Use and try out all the functions and facilities of your equipment in the first few weeks: any faults will then show up within your guarantee period.
- You will go through the first set of batteries very quickly because you are trying out lots of features, so don't worry if they seem to be short-lived. During normal usage, they will last much longer.
- Don't be afraid of the equipment: try out all the buttons, knobs and dials. You will not break anything if you don't force it. And if you change settings inadvertently, there is always a way to return to the default (factory) settings.

What is a digital image?

At one level, a digital image is like any other computer data file: just a long code of ones and zeros. For that matter, if you were to dissect a digital image and looked at the actual code, you would find it impossible to distinguish from the data for a spreadsheet or a letter. Fortunately, it is a whole lot more interesting than that.

Organized data

What distinguishes the data for an image is the way it is organized. You can even open a word processor document as a picture (see below). It's not very pretty, but it is a picture. You can amuse yourself by trying to create a word-processing (WP) document that makes a picture when opened as an image. This leads you to the other dimension of what makes an image a picture of something: the data represents something – what you point the camera at when you make the picture.

DIH AS IMAGE
This is the word-processing file of the page plans for this book opened as an image: it is black-and-white only, naturally. If you opened a different WP file, it would offer very different patterns – each fingerprint-unique to the file.

The next question, then, is how the image is represented in the data file. With a WP document, letters are given code numbers, while their size and position on the page are given other codes – rather like catalogue numbers – which are interpreted by software. For images, we work with picture elements (or pixels) instead of letters.

Pixels

Pixels are not given code numbers, but they are represented in a very specific way: in values of red, green and blue. Various combinations of red, green and blue give us all the colours we need – usually we work with some 16 million different colours. In practice we do not need anything like as many because many colours, which are nearly black or nearly white, are indistinguishable. It is the distribution of pixels, each carrying its own colour, that combine to create a picture. In effect, a digital image is a 'map' consisting of thousands or millions of squares, each one with its own colour. It is easy to see from this that the more squares we have, the more detail we can show on the map. This is an important concept to which we will return more than once.

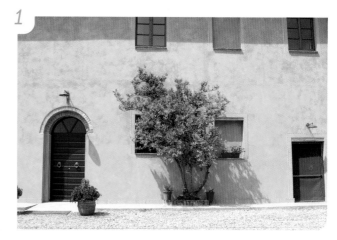

ITALIAN WALL ORIGINAL
With millions of pixels, there is much detail in this image of a country restaurant in Tuscany, Italy. Tonal changes are subtle and smooth.

ITALIAN WALL 10-PIX MOSAIC
With ten times fewer pixels, the image looks less sharp. It is still acceptable, although details will not stand up to close scrutiny.

Flexibility

By taking the image into an abstract realm of numbers and codes, something magical happens. In this in-between world, we can do anything we like to the numbers. And remember that if computers do anything well, they manipulate numbers supremely well. Then, when we turn the numbers back into a picture, what it shows could be radically different from the original – just by changing the numbers. Not only can the colours be changed, pixels can be moved around, distorted in size and simply altered to our whim. That is the basis and power of digital imaging: by working with numbers, our control over the image is well-nigh total and absolute.

3

ITALIAN WALL 50-PIX MOSAIC
Clear deterioration is the result of a fifty-times reduction in pixels. The broad outlines are still discernible, however. You can make out what the image is about, but you can also see the individual pixels.

4

ITALIAN WALL 100-PIX MOSAIC
With even larger pixels – the image is said to be highly pixellated – tonal changes are reduced to big blocks. If you did not know what the subject was, it would be hard to make out the image.

What is RGB?

Red, green and blue are fundamental to digital imaging. For our practical purposes, any colour that we can see can be defined by different combinations of these three colours. Each colour can take any whole-number value between 0 and 255. If all three take the values 0:0:0, we have black. Conversely 255:255:255 defines white. If one colour has a value, while the others are absent, we have a pure colour e.g. 255:0:0 is a pure red and also the strongest. The value 0:125:0 gives us a pure, but not the strongest, green. If one or more colours take on values, we have an intermediate colour such as yellow, or bluish-green, for example. Each pixel is described by the trio of values.

RGB CHANNELS
This is a display of the different amounts of red, green and blue which are present in the image shown below, of a temple in Penang, Malaysia.

ORIGINAL PIC AND CLOSE-UP
Each pixel in the main image has a red, green and blue value. A close-up of the image shows the individual pixels – some with a lot of blue, others with little blue but with much red and green, which combine to make yellow.

Getting started

Much of digital imaging is 'mission-critical': it takes very little for the entire process not to work at all. But don't let that worry you. If you have recently started with digital imaging, you are also in the fortunate position of working with systems that have had most of their problems ironed out. All you have to do is to do what you are told to, when you are told to, and the chances are very high that everything will work perfectly.

Add this book to your camera or other image-capturing device with its instruction book, and you already have the basics to begin digital imaging. You do not even need a printer because in many countries you can order prints from street-front labs. But with a computer and a printer, you can do far more than you thought possible.

This book uses examples from Adobe Photoshop Elements version 3 for a number of reasons. Adobe Photoshop Elements is often supplied with digital cameras, scanners and computers as part of the software bundle. It is a powerful application but easy to use, while its features are common to a wide range of other image manipulation software. Most importantly, it provides a route for you to upgrade to the deservedly standard Adobe Photoshop itself, should you wish to progress further. Many of the features and much of the organization of the two applications are identical.

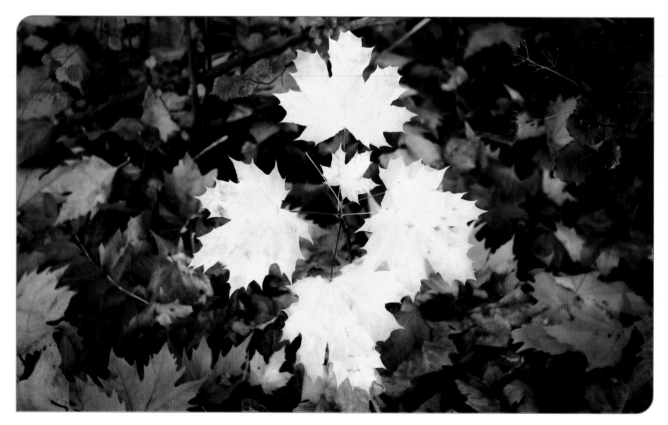

AUTUMN LEAVES VIGNETTED
Digital image manipulation aims to bring out what is already in the image, but showing the image more clearly, or communicating with greater force. Here the already bright leaves were made brighter, while the corners were made darker (vignetted).

How to use this book

This book has been organized along the lines that you will probably proceed – somewhat like a day in the life of a digital image.

If you have no experience at all, the next chapter aims to inspire you by mapping out the amazing range of options you have – many of them literally at the click of a button. When you take your first exploratory steps, do not be afraid to try everything out. You cannot harm the computer. At worst, you may simply have to start it up again. You will learn more quickly by making mistakes than by making none at all.

Now, even if you have some of the equipment, it may be useful to scan through Chapter 3. This chapter covers items which may not be obvious candidates for your shopping list, but the ideas you come across could save you a good deal of effort or worry. Similarly, Chapter 4 helps you to select software to supplement or improve on what is supplied with your digital camera or computer: it is all about saving you time and effort, while increasing your enjoyment.

If you need a condensed introduction to photography turn to Chapter 5, which is a high-speed, concise coverage of much of the basics. It is also an ideal refresher for those who have some experience in photography. Once you have obtained the images, you will need to move it into another machine – computer or printer – to make use of it: that is the subject of Chapter 6. If you wish to share your pictures, you will find Chapter 7 covers the subject: from observing email etiquette to creating personal web pages so that anyone, anywhere in the world, who is connected to the Internet, can view your pictures. Scary thought for some, exciting and epochal for others. And so far, you have not needed to alter or transform your images at all.

For many, the real magic of digital imaging starts with image manipulation – transforming, adding to or subtracting from the content of the image itself. This is the subject of Chapter 8. Here we show you all the basic and most useful techniques, without blinding you with obscurities and effects which fill the waste-bins next to ink-jet printers all round the world. This extensive chapter leads to the output of your images and we will tackle some of the technicalities that you need to understand if you want reliable, high-quality prints.

WHAT YOU CAN DO
with the
digital image

Summary of the process

This chapter maps out the range of what you can do with digital images. Some of this may be exactly what you wish to do; others may leave you wondering who on earth would want to get involved. But you never know: one day one of the techniques mentioned here may solve a tricky little problem at home or at work.

Two worlds

In digital imaging we walk between two worlds: the ordinary world of our senses – also known as the analogue – and the digital. The first step in the basic flow of digital imaging is to capture an image from the ordinary world. This turns an analogue image – what we see – into digital data – the stuff that delights computers. While the image is in the digital world, we can do all the communication, manipulation, storing and transmitting.

Finally, the digital re-enters the analogue world when we make prints or drop our images onto greeting cards, books or posters. In this step the colour information held for each pixel is translated into drops of coloured ink for a printer or as intensities of colour on a computer monitor. This is a complicated process fraught with traps for the unwary.

One disadvantage of the digital world is that to work in it, you need new skills, new knowledge and understanding. But you are fortunate: the technologies are mostly friendly, mature, and broadly reliable. A few years ago we, the pioneers, had to put up with computers that frequently threw tantrums or threw their hands up in the air; we suffered bug-infested software and expensive cameras that gave indifferent results. You, on the other hand, hold thoroughly tested and evolved hardware and software in your hands. Indeed, today's free software could wipe the floor with the professional-grade software produced in the late 1990s.

In recompense, however, it is fair to say that everyone – from professional photographers to those who pick up a camera only for holidays – has been astonished by the versatility of the digital image. If even the experts have been surprised, you are sure to be delighted.

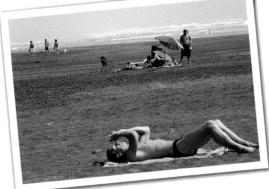

Capture from old: scan

A key factor in digital imaging's success is that it is 'backwards-compatible', that is, old technology is not made obsolete, but can still be used: your family heirloom prints from the 19th century; 50-year-old holiday snaps; all the colour transparencies from your travels. All these can enter the digital world by being scanned.

Most scanners are the flat-bed type that look like a small photocopier. They have a lid that protects a glass platen on which you place a print face down. The most common types will scan up to A4 in size; some portable scanners cover a smaller area and more costly instruments cover A3 size. Today's flat-bed scanners offer superb value for money: machines costing less than a family night out can produce quality exceeding that of machines professionals were once proud to own.

DOUBLE EXPOSURE
Double exposures (two or more exposures on the same frame of film) are not possible with digital cameras. To achieve the effect shown above, you need to make separate digital images and then digitally superimpose them (see also pp128–131).

You can also continue to use film cameras by using film scanners – designed for scanning film, instead of prints. However, there is no need for you to invest in a film scanner. You can ask for scans to be made when you have the film developed. The quality, naturally, may not match what you could do for yourself, but the convenience is unparalleled. Whichever method you choose, the upshot is that you can continue working in both analogue and digital arenas.

Capture anew: digital cameras

It is no longer news that you can make pictures anywhere you like with very compact and easy-to-use cameras. What is often not sufficiently stressed is that any experience you have with using film cameras is transferable to using digital cameras. You may find the many new settings and buttons a little confusing at first, but this is a small price to pay for being able to shoot many more images than with film – uninterrupted by the need to change rolls – which in turn offers a sense of freedom in photography. Its liberating effect is perhaps the single most important advantage of digital imaging.

An oft-cited advantage of digital imaging is its low cost. In fact, the difference between digital and film may not be that great when everything is factored in. For example working digitally, you may make fewer prints, but other costs, such as running the printer and time needed to make your own ink-jet prints, counterbalance the savings. See also Chapter 5.

Process: improve tone, colour, sharpness

Processing the image for improvement is at the core of digital imaging. We enjoy near-total control over every aspect of a picture: every last element or pixel can be changed by you. The entire image can be altered to make it darker, brighter or more contrasty or you can even pick off each pixel one by one if you desire.

The capability it gives you to ensure that your image matches what you see appears to be unlimited. But, of course, the software – however clever it may be – can only work with the data that you have captured in the first place. The more effort and care you invest when taking the picture, the more you will be able to process the image without encountering problems with artefacts – features of the image caused by your processing – or unpredictable results.

Nonetheless, you will have to be quite advanced before you start hitting the quality buffers. Most digital photographers are content to let the software get on with its work without interference from them. If you count yourself among them, you only have to click on the many 'Auto' buttons available, and your wish will be the computer's command. Modern software has become quite 'intelligent', and gives good results with the majority of images.

Your ability to improve the image extends essentially over three dimensions. First is the image tone (the qualities of brightness and darkness) and their distribution or contrast. Secondly, you can control colour: the balance, the intensity

PORTRAIT – DIGITAL IMAGE
This image captured by the digital camera is not too brilliant. Although it has much of the data needed to make an acceptable image, that is not apparent.

PORTRAIT CORRECTED
A few simple adjustments of brightness, contrast and colour make a big improvement, so that it is now quite acceptable – suitable for small prints, website or email use – but it still has many faults.

and the correctness or match to your scene. Third, you have control over the image sharpness: how poorly or well it displays the fine detail that has been captured.

Manipulate: composite, effects, distortions

After image processing, it is a small step to the manipulation of the image. Here, we change the actual content of the image by adding elements taken from other images, subtracting or extracting parts. We can also paint or draw onto the image as if working on paper and loading a brush with paint. We can also distort the shapes and relationships between parts of the image – anything from simple reflections to highly mathematical transformations.

The scale of manipulation can stretch from cosmetic to wholesale transmogrification. Cosmetic changes refer to removing blemishes such as dust spots or tiny fibres, and repairing image damage such as the torn corner of an old print. Going all the way, you can create a digitally modified monster that bears little resemblance to the original.

Many of the effects available are inspired by old photographic processes: these are usually the most rewarding to use, the most resilient to poor taste. But there are numerous other effects which are the invention of digitally adept minds experimenting with computation, rather than motivated by artistic hungers. These effects have their uses, but a close look at a professional's computer will show that the effects have been retired from active service.

How acceptable is change?

How do you regard the removal of unsightly telegraph lines or an errant tree branch sticking out of the left ear of your portrait subject? For some this is a change in content – one which should be announced; for others these are superficial, cosmetic changes. The issue is not purely academic for it goes to the heart of how much we rely on photographs to be a true depiction of what happened in front of the camera. While the issue may not be vital in some areas such as advertising photography, it is crucial in forensic, news and documentary photography.

PORTRAIT – STAINED GLASS
A filter effect – stained glass – applied to the image further transforms the negative image created in an earlier step. The power of digital imaging is that effects are cumulative.

PORTRAIT – POLAR COORDINATE
It is worth trying out some effects for fun, since the results can be quite surprising, if limited in value. This is the polar coordinate distortion filter applied to the original image.

PORTRAIT – GRAPHIC PEN
With the right kind of subject, the effects that imitate fine art techniques can give attractive results that are suitable for printing.

Share and email

In its digital form, your photograph can reach anywhere on the globe very quickly. With the right equipment, you could be in the middle of the Empty Quarter of the Arabic Peninsula or the remotest corner of trans-Arctic Siberia and still be able to receive or send images anywhere on the globe. More modest however – but no less remarkable – is what you can do from your desk-top. Different people have different priorities. If you have family scattered around the world, you may love the fact that you can send pictures of family celebrations – birthday parties, weddings and graduations – to family via email. If you travel, it's great to send pictures home and to colleagues stuck in the office.

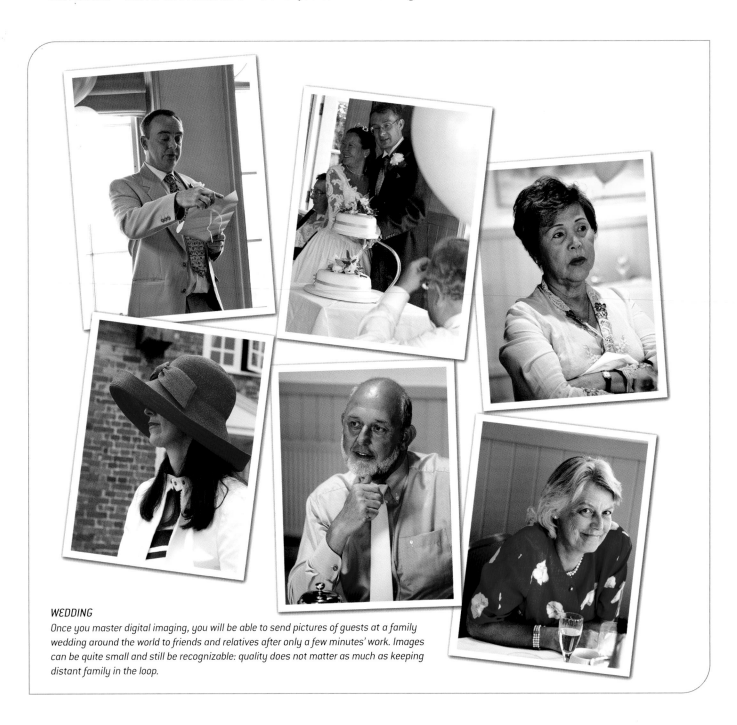

WEDDING
Once you master digital imaging, you will be able to send pictures of guests at a family wedding around the world to friends and relatives after only a few minutes' work. Images can be quite small and still be recognizable: quality does not matter as much as keeping distant family in the loop.

These modes of exchange are essentially one-to-one: an extension of showing a print to someone. But the World Wide Web enables you to reach many people at once. Posting holiday pictures may seem trivial, but when researching a holiday destination, you can learn more about a place from amateur snaps than from the carefully composed and beautifully shot professional pictures (which artfully avoid the building site and major road nearby). If you want to let your holiday home, sell the family silver or invite offers for a valuable first edition book, pictures placed on the web – using your personal web pages or other locations – are effective, far-reaching and very low-cost. See Chapter 8 for more details.

WEBSITE
Modern software applications can automatically create websites to carry your pictures. All you have to do is transfer the data to your Internet Service Provider to use your personal web space and tell everyone where to look.

Using the image

Its very versatility when operating in the digital domain renders your image a fleeting, ephemeral thing. Worse, you have to turn the machine on and drum your fingers while it wakes up before you can see any images. In contrast, the immediate and tactile enjoyment of a fine photo in your hand is second to none. The modern gloss on the print, however, is that you can do much more than a simple print. You can incorporate words of greeting or information with the picture.

Or the picture may take a secondary place to a long text panel or booklet. With today's easy-to-use software you can employ your images within word-processing documents almost as easily as including any graphic or design. All you need to remember is to keep the size and resolution – how much detail is kept – of your images appropriate to the use you intend. And prints make excellent occasional presents. See Chapter 9 for more details.

Presenting images

The digital image has also revolutionized the aural presentation, as pictures help to keep audiences awake while sales projections, ten-year plans and product details are being explained. At home, the equivalent of the business presentation is the digital slide show. This can be as simple as selecting a collection of images and clicking the 'Make Slide Show' button on an application. It can then be shown on your computer or television screen for an audience. In fact, some digital cameras can create a simple slide show on a domestic TV screen.

EQUIPPING
yourself for
digital imaging

The range of digital cameras

The range of cameras now available will meet every need from the simplest to professional quality. As a commodity, digital cameras have joined the office supplies catalogue together with the fax machine, photocopier and coffee-maker. At the other end of the range you can, for the price of a domestic wide-screen TV, a video camera or hi-fi, buy a digital camera that will give you better quality than the late 1990s professional cameras that cost as much as a family car. If you can afford to run a car or attend the occasional concerts or go clubbing, you can afford digital imaging.

The levels

Cameras suitable for beginners (entry-level) are less expensive than other digital cameras, and easy to use. Ease of use refers not only to basic controls, which minimize how much you have to master, but the images are also easier to handle. The images are small in size, lack fine detail and are drawn in such a way that they look appealing, even if they are not strictly, life-like accurate.

Nearly all cameras in this range offer point-and-shoot simplicity: turn on the camera, aim and press the button. You view and frame the image through an optical viewfinder.

Some cameras use an LCD (Liquid Crystal Display) screen on the back to show you what the lens sees.

Next up takes you to a broad band of cameras. These intermediate models offer a good range of camera controls, a wide range of pixel count – the number of sensor elements

F810 FRONT, BACK AND TOP
Digital camera features and controls.

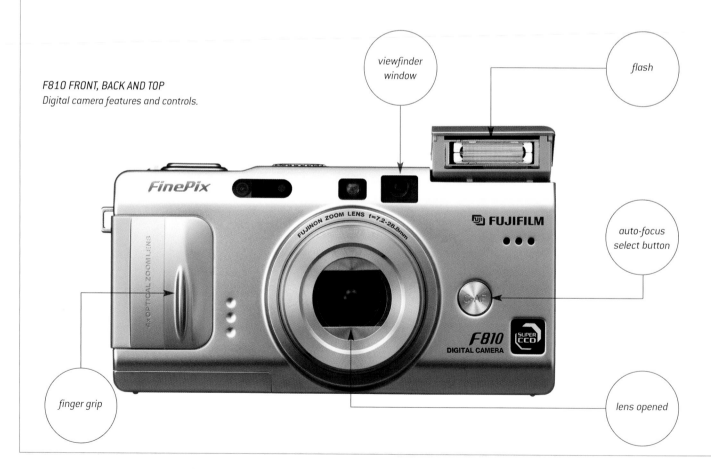

viewfinder window

flash

auto-focus select button

finger grip

lens opened

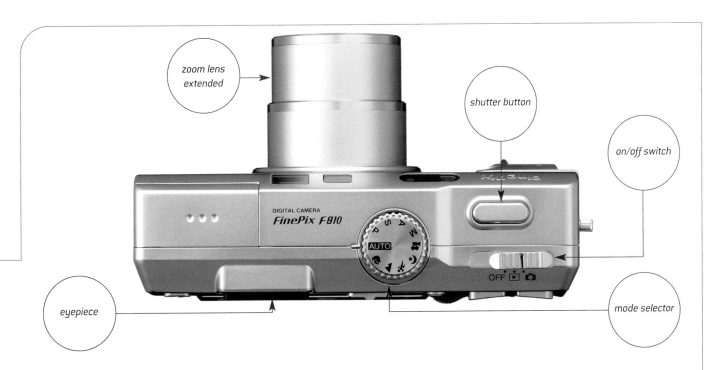

zoom lens extended

shutter button

on/off switch

eyepiece

mode selector

used to capture image detail – depending on how much you wish to spend. And the lenses also offer a good range of abilities and performance levels.

While intermediate-level cameras can produce prints of good quality up to around A4 in size, larger print sizes will stretch their abilities. At some stage you will want a camera

offering not only better ability to capture detail – with higher resolutions – but also one equipped with superior lenses, more precise focusing and that is generally better built. You will get this at the prosumer (professional-consumer) level. These cameras cram a great deal of technology into a small package, and offer superb value.

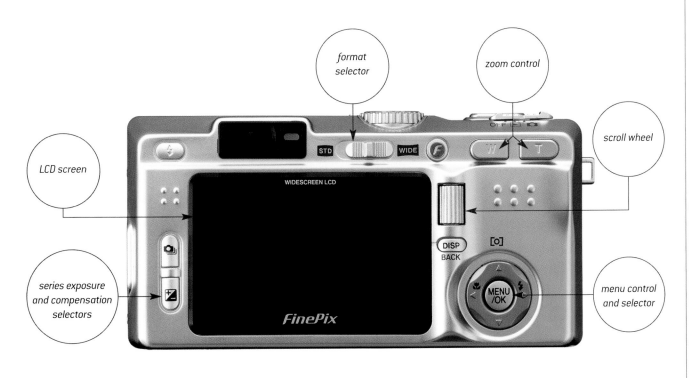

format selector

zoom control

scroll wheel

LCD screen

series exposure and compensation selectors

menu control and selector

Entry-level cameras

Entry-level cameras are the best choice if you intend mainly to use your photos on the Internet – sending or receiving them by email, and if you do not expect to make prints larger than about A5 in size. Modern cameras produce surprisingly few inaccurate exposures or poor focusing.

While it is true that the smallest and simplest cameras have no controls to speak of, most entry-level cameras available today are surprisingly capable. Virtually all offer a tiny built-in flash: this is really sufficient only for taking pictures indoors of subjects within a short distance of the camera. Some models offer a limited zoom – the ability to change the magnification of the image. The tiniest cameras may offer digital zoom: this produces quality inferior to proper or optical zoom, but at this level it can be a useful feature to have.

Tips and hints

When choosing an entry-level camera, look for these features or potential traps:

■ Very small cameras are great when carried, but may not be so handy when used. Check that you can hold the camera comfortably and reach all the buttons and levers easily.

■ Very cheap models may not offer removable memory, which means you have to return to base each time you fill up the memory. You cannot exchange the card for new memory.

■ Check the battery used: is it easy to obtain where you live or can it be easily recharged? Is the charger part of the outfit or do you have to pay extra?

■ Confirm specifically that your camera will work with your computer; do not accept bland assurances that 'it works with any computer'.

■ Is there a printed instruction book? It can be irritating when the instruction book is on a CD and can be read only on a computer.

■ If you buy on the Internet, check that the supplier speaks your language – literally. If not, the instruction book may be in a language you cannot understand.

CANON A310
Cameras such as this are very easy to use, with a single-focal length lens. The latest models can print directly to supported printers. On this camera, a button commands the printing of the currently displayed image to an attached printer.

CANON IXUS IIS
There are many cameras, like this model, that are very compact with limited controls such as a modest 2X zoom. Image quality from 3 megapixels can be surprisingly rewarding, and they are light enough to be carried around all the time.

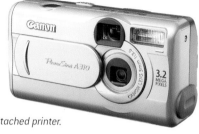

HP M307
Sleek, neat and practical designs are now the norm, like this model that offers 3X zoom, 3 megapixel sensor and a relatively large LCD screen. For improved handling, the entire back is rubberized.

PENTAX OPTIO S30
Despite modest specifications, models such as this 3 megapixel camera can offer 3X zoom, exposure compensation controls, a good range of shutter times and a range of sensitivities.

Intermediate-level cameras

Keen photographers who are looking to convert to digital imaging and those who wish to make prints will need intermediate-level cameras. These offer a good range of camera controls, such as the ability to override the auto-exposure (or even set it manually), a wider zoom range, and a more powerful flash. Above all, cameras at this level offer higher pixel counts, also called 'resolution', for better image quality.

Note that the gain in image quality comes at a cost: the file sizes of each image can be quite considerable when opened in your computer. The word-processor document of a very long novel may reach 1MB (megabyte) in size, but an average digital image is at least 12MB when opened. Higher pixel counts also mean you have to spend more on memory storage for your images.

Fujifilm E510
Typical of a new generation of digital cameras, this model offers a good wide-angle equivalent to 28mm, a 5 megapixel count and a generously sized LCD screen – all in a relatively compact body. The cradle shown here makes connection easy.

ROLLEI DP6300
Classic camera manufacturers also offer digital cameras. With over 6 megapixel count, 3X zoom lens and a good range of photographic controls, models such as this promise traditional quality in construction and high image quality.

KONICAMINOLTA DIMAGE G600
Small cameras such as this offer nearly 6 megapixel count, with a rapid wake time of less than two seconds and the ability to zoom into previews by 12X. Other features include a 3x zoom and capacity to capture 30 seconds of video clips.

Camera resolution

The camera's resolution or pixel count is a key feature. Being told that the camera is, say, '4 megapixel' means that the sensor in the camera collects or samples data from your image at four million separate, different points – in fact four million pixels on the sensor are being used. The implication is that the more pixels, the more detailed the image. Having more or fewer pixels is like being told you can write a report or essay in more or fewer words. With more words you can go into more detail; with a few words, you can only indicate the broad features. But having more pixels does not automatically mean the image is superior: a good writer can explain more in a few words than a poor one in many more, and a good camera can deliver image quality superior to a poor one with millions more pixels.

Prosumer cameras

Special interests such as wildlife, sports or landscapes in your photography will motivate you to acquire a higher grade of camera: the prosumer. It is not only that better-specified cameras can handle the special needs, but special interests also generate a desire for superior image quality. And for that you need a camera that offers higher resolutions – in terms of the sensor and optics, better design and construction, and superior electronics.

Preferred features

You expect a higher level of service from these cameras: smoother, more rapid operation and powerful features. Here are some features you can expect:

- Shutter lag is the interval between pressing the shutter button down and the image being captured. The shorter the lag, the better. If the lag is too long, you miss the timing of peak of action in sports or the exact position of a bird during flight.
- Wake time is how long it takes a camera to be ready to shoot from the time you switch it on. It can be as long as five seconds. The more quickly the camera wakes the better.
- Latency is the interval between the last shot you took and the next one that the camera allows you to take because the camera needs time to process the images you capture. The shorter the better. Modern cameras can capture say, eight images in quick succession, but you then have to wait perhaps 20–30 seconds before you can shoot any more.
- Series exposure is the ability to make several shots each second. It is not something you might use all the time, but imagine yourself on a safari or sports event when a dramatic, once-in-a-lifetime event occurs. You will give anything to be able to fire off several shots within a second.
- Zoom range is the ratio between the shortest focal length and the longest. Generally, the bigger the better: the majority of cameras offer a 3x range, but it can rise to 10x. But what is most useful is if the zoom range starts as wide-angle (seeing over a wide area) as possible. Most zooms start at a 35efl of 35mm (see opposite, below), which is roughly what you can see with one eye closed (but remember the picture frame crops that view to a rectangle). The other end can be as

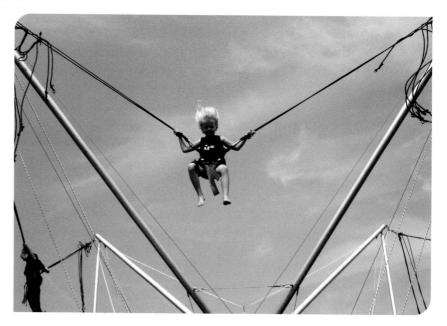

BUNGEE
Timing is all when trying to catch the best moment of a child on a bungee jump – just when their hair is caught by an upward draught of air. Shutter lag makes it tricky to time with precision – you have to adjust for the characteristics of your camera.

KONICAMINOLTA Z2

Prosumer-level cameras are not just about larger pixel counts, but greater versatility. Models such as this, shown with a wide-angle adaptor to increase the field of view, offer a 10X zoom, good range of camera controls allied to a modest 4 megapixel count.

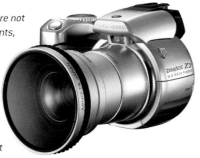

SONY MCV-CD500

The rounded shape of this camera reveals its unique feature: it writes images direct to a CD. This is excellent for business situations which require a level of authentication. Other features such as zoom and 5 megapixel count are similar to other digital cameras.

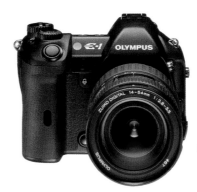

OLYMPUS 8080

Not all modern cameras are sleek and elegant. But don't be put off by appearances; this model offers a wide-angle field of view, excellent image quality with an 8 megapixel count and full camera controls.

OLYMPUS E-1

This model is the first in a generation of compact cameras with interchangeable lenses: with a near 5 megapixel count, and growing line of professional-grade lenses, this camera effectively serves the needs of the most demanding enthusiast and full professional.

much as a 35efl of 350mm: this magnifies the image about as much as a pair of 7X binoculars.

- Image stabilization is a way to correct for camera shake – the small movements during exposure which spoil image quality. Stabilization becomes essential when focal lengths exceed a 35efl of 150mm. If you have a choice, prefer cameras offering image stabilization.

- Memory cards store the data for your images. There is not much to choose between them. All are small, some may be flimsier than others, but generally all are highly reliable and offer good value for money. The exact type matters only if you use more than one camera, or a video camera, for then it pays to be able to use the same card in both cameras.

Equivalent focal length

Most people are familiar with the focal lengths of 35mm camera lenses. Also, the focal lengths on all 35mm cameras are the same for every lens length, because the size of the film is the same on all of them. In digital cameras, however, the size of the image sensor varies from camera to camera and therefore the focal length will differ for the same lens length. Expressing focal lengths in terms of 35mm equivalent makes it easier to understand and compare digital camera lenses. Whereas the true focal length of a digital camera may be, say, 10mm, it may give an area of view similar to that of a 50mm lens on a 35mm film camera and is therefore described as having a 35efl (35mm equivalent focal length) of 50mm.

How to use the features

The best way to understand the usefulness of camera features is to try them out for yourself. You may see no point in making voice annotations for pictures – until the day you need to note some details with a picture you shot but have no pen or paper handy. You may see no need for lens accessories – until you need to make a shot of a small room and cannot get it all in, or you go on a nature holiday and find the bird is too far away for your lens.

Practise with the camera

The best way to learn how to use the features is to go through it all systematically. Remember, you will not be wasting any film, so shoot away and review the images to check results.

1. Turn on the camera: note how long it takes before it is ready to shoot.
2. Look through the viewfinder to get used to it. Or view the LCD screen: if you need glasses for reading, you will need them for the LCD screen.
3. Try different settings and press the shutter button. Review the results on the LCD screen.
4. Try different quality settings (often labelled 'Best', 'High', 'Good' … but never 'Poor'!) and take pictures. Open these pictures in the computer to learn about their differences.
5. Play with the lens zoom control to familiarize yourself with its speed and smoothness.

CLOSE-UP
Digital cameras focus very easily to extreme close-ups, but you may need first to set a close-up mode – usually indicated by the symbol of a flower.

Read the instructions

Instruction books constitute some of the most indigestible literature ever written, but unless you read them, you may waste at least half the capabilities of your equipment. Do not try to read the whole thing in one sitting, and not when you first purchase the camera. Not even technology journalists can cope with that. Read the installation or 'quick-start' sections first. Read and obey the warnings about what not to do (e.g. not to remove the memory card while its light is on). If anything puzzles you when you try out different settings, that is the best time to refer to the instructions. If the instructions are on a CD, it is worth printing them out.

Other functions

It would take an entire book to describe all the functions offered by today's cameras. Some of the more useful are:

- User-set resolution: you do not always need the highest resolution. It is useful to be able to set lower resolutions to suit the job in hand (see p57). Compression – reducing file size through computation – may be varied to make files even smaller. High-quality equates with less compression giving you larger files, while more compression gives you smaller files but leads to lower quality.

- Video clips: many cameras can capture short videos (moving image films). Quality is limited by the need to keep the file size low. Usually, the lens setting and other functions cannot be changed during filming.

- Voice recording: some cameras can record a short voice memo – useful for annotating pictures as you take them.

- Make several exposures in rapid succession: this makes the most of digital imaging's parsimonious ways with materials as you can take lots of pictures without worrying about using up film. Some cameras can take several pictures per second but may then need a couple of minutes or more before they can make any further exposures, whereas others don't shoot as fast but can shoot without interruption. You have to decide which you prefer.

- It can accept lens accessories to extend the usefulness off the zoom.

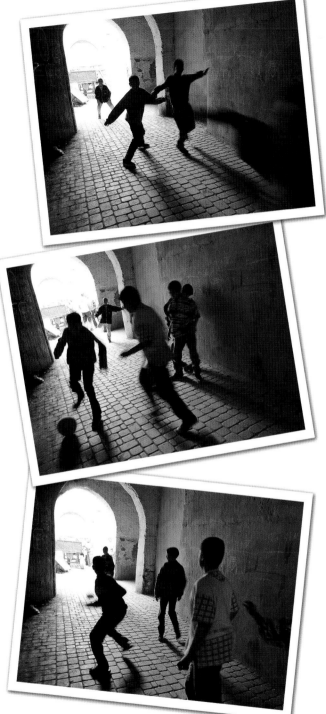

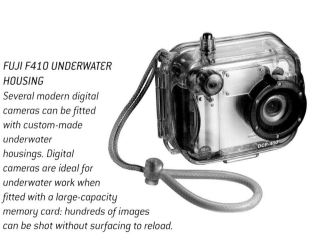

FUJI F410 UNDERWATER HOUSING
Several modern digital cameras can be fitted with custom-made underwater housings. Digital cameras are ideal for underwater work when fitted with a large-capacity memory card: hundreds of images can be shot without surfacing to reload.

FOOTBALL
Making a series of pictures rapidly is useful for following action, like these boys playing football in a street in Marrakech, Morocco. Many modern cameras can shoot three or more frames per second.

Trouble-shoot: using the camera

Modern equipment follow a so-called bath-tub curve describing their reliability. This means that if a digital camera, video or computer, etc. will fail at all, it is likely to do so in the first few weeks of use. Thereafter, it will be reliable for almost all of its designed life span. The up-shot is that you should try out your equipment heavily in the first few weeks.

Fault	Camera does not work at all.	Battery appears not to last a very long time.
Explanation	The most common reason for a camera not starting up at all is that the batteries were inserted the wrong way round. If the batteries are keyed (can go in only one way) then the next likeliest cause is a flat battery. Some cameras will not work at all if no memory card is inserted or if a door – often to the memory card – is not properly closed or the lens cover is not fully opened.	Batteries packed with the camera may not be fresh or have only a small charge. If the camera uses rechargeable batteries they will have only enough power to start the camera up, but little more. In addition, you will use the camera very heavily at the beginning. Battery life is always shortest at the beginning of ownership.
Strategy	Don't blame anything or anyone. At any rate it is almost never the fault of the camera. Check the Quick-Start instructions to see that you have inserted the battery correctly, pressed the correct button (sometimes the on/off switch is not obvious), and everything is as it should be. Charge up the battery: most camera batteries are supplied uncharged.	Buy good-quality batteries as generally they last longer. Avoid using the LCD screen for reviewing every picture you take, since this generally uses up a lot of power. If the camera uses rechargeable batteries, charge them fully before playing with the camera. Then run them right down – until flat – and recharge fully for the first two or three cycles: this helps increase their longevity.

BATTERY CHARGER
Modern battery chargers are compact and many can work rapidly by careful monitoring of the battery condition.

FUJI E510 BOTTOM
Cameras that use standard AA or AAA batteries are easily kept powered, but you have to be careful to insert the batteries correctly – in this case there are no fewer than three ways to get it wrong.

Fault	With night shots, the camera's flash goes off, but the images are still very dark and under-exposed.	The camera takes a long time to wake up or there is a noticeable delay before the shutter fires.
Explanation	The flash built into digital cameras produce only enough light to brighten up a subject 2–3m (6–10ft) from the camera. No flash in the world is powerful enough for proper exposure of distant night scenes.	Electronic cameras need time to power up because they have to 'boot up' just like a computer, and check that all systems are working. Some will need as many as five or more seconds: older cameras took even longer to start. The delay before releasing the shutter is again because focusing, exposure and other factors are being calculated. If the camera is behaving differently from when you tried it out in the shop, then have it checked by the retailer. There may be a fault with your memory card.
Strategy	Turn off the auto-flash if possible, to conserve battery power. Set the camera on a tripod or stable surface so that there is no camera movement during the long exposure – which could last many seconds. If available, set the camera to a high sensitivity (to ISO 800 instead of the usual ISO 100), although many cameras will automatically increase sensitivity with low light.	There are ways to reduce the time lags. The start-up time is difficult to reduce, but can be helped by switching off features such as automatic flash and custom settings (returning the lens to the setting at power-down instead of its standard position). Using a smaller memory card or a high-speed one may also help. To reduce shutter lag, turn off – where you can – automatic functions that you do not need (auto-flash, auto-focus or auto-exposure).

LOW LIGHT – SUNSET
The low light just after sunset will trigger the flash on the majority of digital cameras. But it will be a waste of energy and the exposure could easily be too short, causing a disappointingly dark image. Better to set the camera on a tripod or other stable surface and turn off the flash to obtain an image like this.

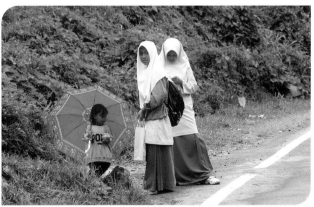

TIMING – GIRLS ON THE ROAD
Taking snaps from a moving car – like this one taken in Sabah, Malaysia – is tricky at best, but is really difficult if your camera is slow waking up. Let the camera 'sleep' or idle, rather than shutting it down.

Other cameras

The core of a digital camera – including the lens and all the electronics – can be crammed onto an integrated chip smaller than a fingernail. The camera body is made bigger only to accommodate controls big enough for our hands. It is therefore no surprise that digital cameras have snuck into every nook and cranny that modern technology offers.

Attachments

Digital camera attachments can extend the usefulness of electronic devices. With personal data assistants (PDA) you can store images together with diary, address and notebook data. Attached to media players, you add digital photography functions to the ability to store a great number of files, play music and watch video. One big advantage of these is their very large LCD screens compared to those even on the larger digital cameras. But neither their image quality or usability can compete with proper digital cameras.

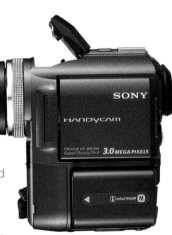

ARCHOS JB20
This compact, portable box is essentially a hard-disk drive with software that allows you to download files and play music files through headphones.

ARCHOS CAMERA ATTACHMENT
This small camera with basic lens and capture device clips onto a media player which holds up to 40GB of data, and plays music.

Digital video

Images from digital video cameras with 2-megapixel counts and better will give acceptable-to-good stills, but none are as good as even an inexpensive digital camera of equivalent pixel count. The best way to capture a stills image on a video camera is to store the stills image on a separate memory card – just as on digital cameras. Avoid cameras that store the stills image on tape. A few cameras consist of a video and digital camera fused together, with separate lenses but some shared controls.

Modern digital video cameras can pack in not only a high-quality video camera but also a 3-megapixel count sensor for digital stills. Image quality can be very good indeed, with pictures captured – in this case – on MemoryStick, but operation is not as rapid as even with basic digital cameras.

SONY 330

Cellular phone (mobile) cameras

The majority of images shot by camera will be taken by a mobile phone. The digital camera parts make no significant difference to the size or weight of a mobile telephone – and do not make a significant difference even to the price. Factor in the fact that it is as constantly at your side as the phone, then it is plain the mobile phone could drive bulkier cameras into a niche.

MOTOROLA MOBILE PHONE
You can capture images in full colour, and review in colour. Image quality is on a steady rise, with new technologies such as ceramic lenses improving compactness as well as lowering costs.

Of course, a picture in a phone is in a state ready to be sent to other phone users. And their convenience can extend to printing too. Units with Bluetooth wireless capabilities can send files direct to Bluetooth-compliant printers for printing.

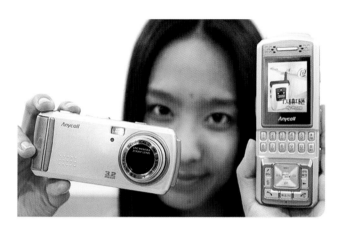

SAMSUNG 3MP PHONE
Phone camera and camera are shown side by side because they offer similar pixel counts. However, the phone offers communication abilities, while the camera has superior photographic features.

Web cams

Moving pictures can be transmitted between computers with increasing ease and, with that, the capture of any stills image whenever required. The key is high bandwidth – the capacity of communications networks such as phone or cable lines to carry data. Moving pictures generate vast amounts of data and these have to be processed, compressed, transmitted, then re-processed – all at a speed that allows motion to be displayed.

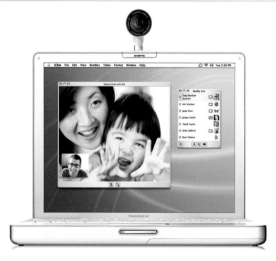

ISIGHT + ISIGHT IN USE
The size of a fat pen, the Web cam can link people with moving images of each other: the small one shows what your partner sees (can be off-putting to see yourself) and the main screen shows your partner. The system needs suitable software, which usually comes with the Web cam, and a fast Internet or local network connection.

Computers and computing accessories

The important, and impressive, fact is that any modern desk-top computer – and the vast majority of lap-top computers – will work digital imaging very well. This is remarkable because digital imaging files are far, far larger than any other computer file ordinarily encountered by the user. The space taken up by hundreds of letters of a prolific letter-writer over an entire year, for example, would still be a fraction of a single file from a modest 3-megapixel camera.

PC versus Mac

Over 95% of desk-top computers run on various versions of the Windows operating system, or platform. The rest are made up largely of machines running various Mac OS incarnations. It is fashionable to say that there is little to choose between these systems. They are fast, stable (do not crash very often) and both are easy to use, extremely powerful and grow as your needs develop. Nonetheless, neither is perfect and it is worth remembering that you, working in digital imaging, are actually straining at the limits of what the average personal computer can do. Nonetheless, if you were to ask me for a recommendation, I would unhesitatingly recommend Mac OS.

APPLE MAC
Apple Mac computers are more expensive than even a well-specified Windows machine, but the software bundle is wide-ranging and far more powerful than that offered with Windows. Macs are also sold ready for the Internet and networking, and its operating system is arguably far more elegant and powerful than that of Windows. Modern machines are uniformly of very high quality and reliability.

COMPUTER

There are numerous different models of Windows-compatible machines, which vary greatly in quality. A very wide range of software is available, but spare parts of less well-known machines may be difficult to find. An inexpensive machine may turn out costly once you add components as your needs grow. Software and hardware installation may not be straightforward.

Operating system

All computers use similar and even identical components. And even different components can be made to do the same thing given the right instructions. The set of instructions that organizes the activities within a computer, administers its relationship with connected devices, and allows you to tell it what to do, is the operating system (OS). For our purposes, there are just two – with various flavours of Windows and of Mac OS X (Mack oh-ess ten), with Palm OS as a small runner-up dedicated to small PDA devices, followed by Linux OS run by technophiles.

Archive and storage

As you progress with digital imaging, you will discover that what you thought were billions and billions of bytes of storage space in fact amount to only a few hundred images.

Furthermore, you will discover that the memory card supplied with cameras is wholly inadequate for your needs: you will need to buy more.

Computer storage

You store your working files on your computer's HDD (hard-disk drive). Modern machines typically ship with a 40GB (gigabyte – million megabytes) capacity HDD, but that 40GB is soon filled up. Inexpensive extra HDDs can be fitted easily into the majority of desk-top machines. Slightly more costly external HDDs are even easier: just plug in the power, and plug into your computer. Ensure the drive connects with FireWire. Drives which are bus-powered – i.e. do not need a separate power supply – are most convenient.

MOBILE DRIVE PENCIL
Modern HDDs are compact, capacious and easy-to-use. Just plug into the computer and it will appear as a drive. Always eject the drive properly before unplugging it, and never unplug while a red warning light is flashing: you could destroy all data.

Camera storage

With the many types of memory cards available – with some confusing nomenclature such as xD and SD cards – you need to ensure that you purchase the type that fits your camera. For each type, the best value cards – in cost per unit of memory – are usually those near the maximum capacity, but not the biggest. Unless you are using high-pixel count cameras, it is not worth buying faster cards – designated by, for instance, 20X or 40X speed.

MEMORY CARDS
There are several types of memory cards which share only the property of mutual and irritating incompatibility, yet differ hardly at all save in size and shape. Performance, price, reliability are very similar across all types and brands.

Volatile and static memory

Volatile memory needs to be kept alive – with electricity – whether it is in your brain or the innards of your computer. Static memory, however, is like writing on a piece of paper: it does not need electricity to be kept, though it does need to be read and interpreted to be useful. The main type of static memory in a computer is the hard-disk drive. Digital cameras use flash memory: the registers that hold the data turn on or off only on receiving an electrical signal, so they keep their state or memory without power.

Scanners

Scanners are good news for the many photographers who have stacks of film and prints in old shoe boxes. Scanners enable you to turn 'legacy' material (pictures on materials like film and paper) into digital images.

Flat-bed scanners

Even better, you can turn any flat material such as maps, newspaper cuttings, love letters and old prints or drawings into a digital image. The only limit is the size: the vast majority of scanners accept a maximum size of A4 (about 210mm by 290mm). If your original is larger, you either need access to a large scanner or scan it in sections, and join up the parts using image manipulation software. This gives mixed results, but is better than nothing.

CANON LIDE35 SCANNER
Simple modern scanners such as this offer results that would have pleased professionals a few years ago, but at a fraction of the price. These models offer superb value, with powerful built-in automatic features such as dust removal and colour correction.

CANON 9900F SCANNER
Highly capable scanners such as this model offer high resolution to obtain the finest detail from originals, good colour reproduction as well as convenience features. Some scanners can automatically crop the scan area to fit your print, and prepare files for emailing, saving or printing.

HP 1200 SCANNER
This tiny, battery-powered scanner from Hewlett-Packard is highly portable and can be used anywhere – to scan anything from business cards to flower heads and sea-shells.

Film scanners

Flat-bed scanners can produce, at best, acceptable results with colour negatives, but results from black-and-white negatives and colour transparencies are likely to be disappointing. The solution is to use a film scanner. Inexpensive models are available, rising to much costlier but superior machines.

NIKON COOLSCAN V
The more costly film scanners, such as this model, can give you excellent results with colour negative film. These can earn their keep if you have a large collection of good- to high-quality film.

Dust removal

When you scan to extract the details in your photos, you will also pick up sharp images of the dust and micro-fibres on your film or print. Many modern scanners have systems which 'remove' specks automatically, using infrared light and special software. Select, if you can, scanners – both flat-bed and film – that offer this feature.

Printers

The relationship between printers and consumers has been rather turbulent, with expectations running ahead of ability.

Nonetheless, once tamed, modern printers offer really remarkable print quality at relatively low cost.

Ink-jet

The standard technology uses tiny ink-guns which squirt microscopic drops of ink onto paper. There is no substantial difference between the three or four different methods of squirting the ink. However, there can be significant differences between the inks: using low-quality inks can impair not only the accuracy of colours and repeatability between prints, but prints may also not last long before fading. It is not worth economizing on printing inks when the basic cost is already so low.

CANON I80 PRINTER
Modern ink-jet printers are not only capable of brilliant results, they can be very compact and even portable, with some models being powered by rechargeable batteries.

Computer-free solutions

Whereas it was always assumed that printers were devices peripheral to computers, and therefore needed to be connected to one to work, the situation is now that computers are increasingly becoming redundant. There are increasing numbers of printers which will print direct from a camera or inserted memory card while the computer snoozes away inactive and unconscious.

Some printers do not even have to be connected by wire – they will pick up a signal sent from a nearby mobile phone: you simply need to register the phone as an appliance recognized by the printer, and vice versa. Others will pick up an infrared signal from any compatible device such as a PDA (personal data assistant).

EASYSHARE PRINTER DOCK
To print from compatible cameras, you need only seat the camera into the dock on the top of this printer and press a a button or two. Some printers of this type use a very compact system that produces near-photographic results.

All-in-ones

As the population of devices on your desk-top grows, so does pressure on its real estate. All-in-one, or multifunction, devices offer a solution by packing a scanner, printer and copier all into one box, sometimes throwing in a fax machine as well. They are very good solutions for the home office, and there appears to be no significant compromise in quality of their functions, although they may operate more slowly than single-function machines. Certainly, there is no cheaper way to obtain a colour copier, and once you clear the clutter off your desk, you won't want to go back.

EPSON MULTI RX500
They may not be the prettiest of machines, but these compact behemoths are masterpieces of integrated technology. Although they may not deliver the speed and quality of dedicated machines, they save considerable amount of desk space and clutter from separate connectors and leads.

SOFTWARE FOR
digital imaging

Survey of software

One of the driving forces for the rapid rise of digital imaging has been software development. This has put great computing power under the bonnet, but at the same time created easy ways to drive the application. And all has been aided by the increasing speed and processing capabilities of modern computers.

Basic software

Paradoxically, the easiest software to use may offer many features absent from 'bigger' applications. ArcSoft PhotoImpression, for instance, offers projects (such as cards and calendars), slide show production, many automated features, and extra images or clip-art. ArcSoft PhotoStudio offers more image manipulation features, as well as 3D text effects and batch-processing (changing many images without supervision).

ARCSOFT PHOTOIMPRESSION
Inexpensive, but offering enough features to keep anyone amused for many hours producing slide shows, working with clip-art, text effects and projects such as cards and calendars.

ARCSOFT PHOTOSTUDIO
Photostudio offers not only image correction tools, but also special effects such as 3D lettering and varied printing options, including templates for greeting cards or calendars.

Intermediate and advanced software

Paying more for software obtains not only more powerful features, but also the important smaller ones such as short-cuts based on keyboard strokes, which make working much more efficient. ULead PhotoImpact is notable for its abilities with web animation effects. Roxio Photosuite is also a capable application that has good integration with CD creation and picture-sharing applications. Better software also tends to work more smoothly and responsively. A popular application, lacking no power for the enthusiast, is JASC Paint Shop Pro. It is fairly easy to use and has not suffered from imitating Photoshop as closely as it dared.

PAINTSHOP PRO DUTCH
Popular and inexpensive, some versions are made more attractive by having other software bundled. It has a good user base, with much support and many fora on the Internet to help you gain the most from the program.

Adobe Photoshop

After a few years' struggle, with other image manipulation software trying to topple it from its perch, Adobe Photoshop is now indisputably the most widely used, best-known and best-understood software in digital imaging. It is one of the best-written software applications – irrespective of type. It is extremely stable, flexible, logical in use and it is possible to learn how to be productive with it in a short time. Its functionality has been enhanced by plug-in software: applications which work within Photoshop as if they were simply another menu item. However, Photoshop requires vast computing resources to run well. And there remain some tasks which are better done by competing products such as Binuscan PhotoRetouch, Equilibrium DeBebalizer and Corel PhotoPaint or Corel Painter.

If you aspire to serious work in digital imaging, you cannot get far without Photoshop. In this book we illustrate techniques using Adobe Photoshop Elements, a trimmed-down version: everything you learn in Elements you can apply to Photoshop. Indeed, when you start to be impatient with its limitations, you know you are ready for Photoshop.

PHOTOSHOP
The industry-leading digital imaging application is now in its eighth version: rather expensive, very large and highly intimidating to the novice, it is nonetheless the standard by which others are judged – and usually found wanting.

Fun and specialist software

As people think of, or want, new things to do with images, so applications proliferate to serve them. Chief of them is software to create panoramas, but others have developed too.

These are good fun to investigate when you have mastered the fundamentals of digital imaging.

Photomosaic

Photomosaic is an increasingly popular way of creating intriguing images. It is a special type of montage in which hundreds of individual images work together to make up a larger, different image. Looked at from close-to, you see individual pictures; but from further away, another image – often totally different – emerges.

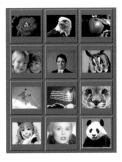

PHOTOMOSAIC LIBRARY
A small section of the library of small images used to build the photomosaic: the more images you have, the richer the final product. And, of course, the library images can be made relevant to the main image.

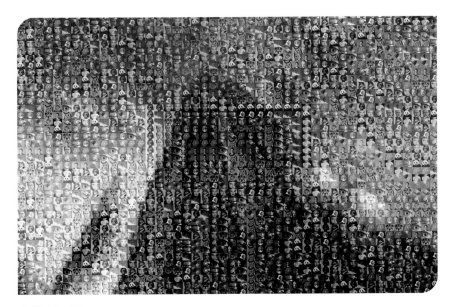

PHOTOMOSAIC
The result of using the gallery of pictures (see right) to reconstruct the original image of a skyscraper in Paris, France seen through coloured filters.

ORIGINAL
The original image is used as a map to guide the software as to where to place the mosaic images. Images with clearly defined shapes work best for this technique.

Panoramic software

The frustration of being unable to take in a whole horizon – a sunset on a Pacific coastline, a vast savannah vista or snowy peaks from a mountain top – is now ended. You simply take a series of pictures from one side of the view to the other and 'stitch' the images together to create a panorama. What the software automates – though you could do it yourself – is the matching up of features at the overlaps. See also pp136–7.

Many digital cameras provide panorama-making software bundled with other software. If you are really keen on them, try powerful specialist applications such as PanaVue Image Assembler or RealViz Stitcher.

Useful software for digital imaging

Some are dismayed, others delighted, to learn that once one piece of software is mastered, there is another eagerly waiting in the wings to be helpful. But you have to learn how it works before it can be useful.

Organizing pictures

One of the most interesting developments in software for digital imaging has been the growth products for image management. Not long ago, the need to organize thousands and thousands of images was the concern only of large publishing conglomerates. But now that the typical enthusiast can return from a safari or beach holiday with hundreds of pictures, the need for software to help out has become their problem too.

Most applications such as ACDSee, iView Media and Photoshop Album are designed for the single user, who does not need to communicate or share libraries with others. This enables the software to be quite simple yet capable of sorting through thousands of images very rapidly to order them by name, date of creation or modification, or by keyword. More sophisticated applications, such as Fotoware Fotostation or Extensis Portfolio, are worth considering if your collection is large and complicated.

Management software can do useful tasks such as changing the names of a whole lot of images, adding a cumulative number. Tasks such as turning dozens of pictures so that they do not lie on their side can be carried out in a few mouse-movements. Some can prepare a set of pictures for publication on the Internet.

ACDSEE
A popular, compact and rapid-working image management application, though it is not easily customized. Windows only.

ADOBE PHOTOSHOP ALBUM/WHITE
Despite being a late entry into the market, it has rapidly become one of the most popular. Windows only.

IVIEW MEDIA
Neat, fast and quite powerful, it offers slide show features and other conveniences. For Mac OS X and Windows.

Keywords

Most digital cameras add EXIF data that record facts like the name of the camera, the camera settings, resolution, use of flash and so on. This data can be searched by management software. In addition, you can add your own key words (such as leopard, rocky outcrop, sunset) which can be searched. These additions are the so-called meta-data which make it so much easier to find pictures years later.

Burning CDs

Now that CDs (Compact Disks) are the cowrie shells of information technology, it is well-nigh essential for anyone in digital imaging to be able not only to read them but to create them. Owners of modern Apple Macintosh machines can burn CDs straight out of the box: their computers are equipped to burn CDs (and many can burn DVDs too) and software is provided as part of the operating system. Other computer users will need to buy external CD writers that plug into the computer, and are driven by CD-burning software. Beware that not all CD writers are supplied with suitable software, such as Roxio Toast.

TOAST 6
The most popular and certainly easiest CD-burning software available: you click and drag your file into the application interface and it is ready to be copied (burnt) onto the CD. Many formats and options are supported.

Scanning software

All scanners are, of course, sold with software to run them from the computer, the so-called driver software. However, some of these are poorly written, error-prone, give poor results and are ugly, to boot. Thus a small market has developed, offering alternative software. The most popular is Hamrick VueScan, thanks to its high quality and low price. Taking higher ground is Lasersoft Silverfast which can be used with any model from simple scanners through to professional ones. This provides a clear path for up-grading: it is handy not to have to re-learn software when you up-grade a scanner.

Shareware

Shareware is the best source of inexpensive but useful software; indeed, some are better than equivalent commercial products. You need an Internet connection to download the software. Once you install it, you can try it for a time, after which it will ask you to contribute a payment. If you like it, you register by paying a small fee. This unlocks the software, removing the reminder to pay. You may continue using the software beyond the period, but it will continue to 'invite' you to pay.

Trouble-shoot: software problems

We have left behind the days of software so poorly written that it frequently crashed or froze for no explicable reason. Freezes and crashes still occur, but much less frequently, and usually because of error or rushed action by the user. This means that where software fails to work, it is usually within your abilities to solve the fault.

Rare glimpses of corrupted files: normally, even the slightest fault will make a file refuse to open. The top image shows the lower half of another image, with colours and tones reversed: one error half-way through a list could corrupt the remaining half. The chess-board image shows a number of pixels shifted in position.

Fault

You ran the installation, but the software does not take up residence, or does not appear to work.

Explanation

Software for installation is generally very reliable. Difficulty in installing software is usually due to a factor in the computer that inhibits or blocks the installation. Or the installer may be looking for a particular file or folder which, if absent, causes installation to abort.

Strategy

The key is to leave the installer a clear field to work in. Quit all other applications. Turn off virus-protection software. If your computer is a few years old, the operating system may need up-dating: consult the website for the operating system and download any up-dates. An unsuccessful attempt at installation may leave files which need to be removed before re-installation is attempted: if so, the installer will offer an Uninstall option. Run the Uninstall before attempting to install again.

The computer runs very slowly, so that simple actions or commands like opening a file takes ages to complete.

The computer crashes. It stops working altogether or reboots (closes down and starts up again) when you try to do something.

Slow operation of computer or software often has obvious causes: the system is overloaded in one or more parts. But it could be caused by deeper problems such as poorly written software or some minor conflicts in the system.

You probably have a problem with either the software or a component that the software is trying to reach (printer, camera or modem). Try to remember what you were doing before the crash sent you into a panic, and make a note. If the problem occurs soon after you install new software, uninstall it and try to reproduce the crash. A stable computer now suggests the new software is the culprit: try to obtain up-dates.

It is easy to overload even professional-grade machines with large image files. It is easy to create, in error, files which are far too large. Usually, the most effective way of improving your machine's performance is to install more random-access memory (RAM) – little modules on small cards that slot into receiving sockets inside the computer. You can improve performance by increasing the capacity of your hard-disk. And performance usually improves when all the software is in their latest up-dated version (not full version, but the latest sub-version; in other words, version 4.11 is preferable to 4.1).

With your note in hand, and serial number of the software, contact the Help Desk of the software or computer. Consult the support pages of all relevant websites – from an Internet café, if necessary. Above all – as a precaution – save your work as you work, and keep saving, and save before you break for a drink or rest, save before you shut down, save while you think about it and even before.

Setting up your work space

Unlike traditional photography, digital imaging does not demand a dedicated space more or less permanently. Better, if you do devote space to it, you create an efficient home office at which lots of other work can be done.

Where to put the computer

It is obvious that your desk should be stable and solid. Place the printer somewhere else – on a shelf above, for instance – since its operation can shake the desk. The computer can be placed on the floor if it is not too dusty.

Also, the further away the computer is from where you sit, the less distracting the noise from its fan will be. However, in that case reaching for the CD tray may be less convenient. Try to keep the keyboard in a straight line between yourself and the monitor screen. If it is at an angle, your body tends to work at an awkward angle that will lead to aches and discomfort. And leave space for the mouse-mat or mouse as close to your keyboard as possible to avoid stretching more than you need.

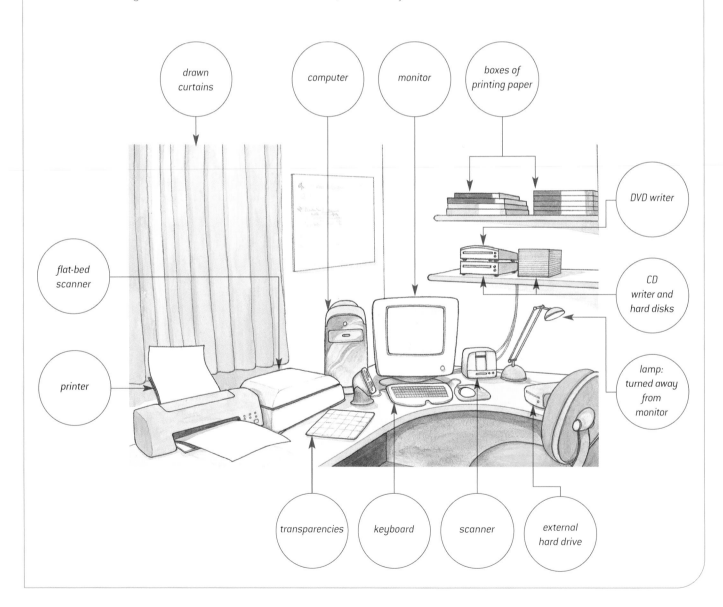

drawn curtains

computer

monitor

boxes of printing paper

DVD writer

flat-bed scanner

CD writer and hard disks

printer

lamp: turned away from monitor

transparencies

keyboard

scanner

external hard drive

Siting and seeing

Light coming onto the monitor screen from anywhere but the screen is inimical to accurate digital imaging work. It is best to site the screen so that light from windows comes from the side, never from in front or from behind you. In fact, like the traditional darkroom, digital imaging has a predilection for the dark. While the work space does not need to be completely light-proof, it should ideally be too dark to read a newspaper.

And in a perfect world, the walls of the room will be neutral in colour.

All of this gives you the best chance of assessing the screen image accurately. This, as we shall see, is a key element to ensure that you produce accurately coloured images. If you cannot darken the room, at least try to work only in the evenings. It follows that if you use a desk lamp, it should not shine onto the monitor screen.

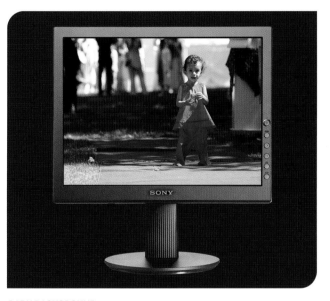

DARK BACKGROUND
Seen against a dark background, the image appears richer, with more contrast and sparkle.

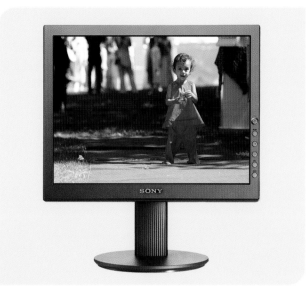

LIGHT BACKGROUND
Seen against a light background that is tinted, the image appears less rich, with lower contrast. There will be a temptation to 'improve' the image's contrast and colour.

Keeping it all working

- Do keep the work place a pet-free zone: fur and dust are serious enemies of high-precision technology.
- If you live in an area with unstable mains power or prone to thunderstorms, plug the power lead for all items through a multi-gang socket that offers surge protection.
- Keep the working area clean, and if you have to eat or drink at the computer, place the cups or glasses on a separate table.

- Keep your monitor screen clean: wipe regularly with a dry optical cleaning cloth of the type given with spectacles to remove accumulated dust. On CRT (cathode-ray tube) monitors, dust builds up very quickly.
- Keep yourself working by taking regular breaks – at least 10 minutes every hour – away from the computer: stretch, look out of the window, have a drink.

Setting up the monitor

You can go a long way with digital imaging, and have a lot of fun, without worrying the slightest bit about the quality of the image on your monitor. Besides, monitors from today's reputable manufacturers give you remarkably high quality images. As your skills develop, however, your eyesight will become more acute and your demands on the image will grow. One day you will want to ensure that the monitor image is as accurate as can be. This section is for that time.

Calibration

You calibrate a guitar when you tune up one string, using a concert pitch tuning fork as standard reference, then tune the other strings using the first string as reference. So calibrating a monitor is the process of adjusting controls to make the image on screen match a standard. You are fortunate in that the process is now well understood, and you get a lot of help from software. You call up the Control Panel for monitors in Windows and follow the instructions for calibration. Similarly, with Mac OS, you go to the 'Colours' section in 'Displays', which is found in 'System Preferences'.

The steps

The basic controls affect the brightness and contrast of the monitor image: we want a monitor that is as bright as possible to give the contrasts we need. Then we make sure that colours are balanced, so that a grey in the image is shown truly grey: this is the colour-balance control. Next the gamma sets the way the monitor interprets the video signal – it is analogous to the tone control for audio equipment: it sets the basic character of the image. The human eye does not respond linearly to light, it responds to linear brightness or luminance differences. Gamma describes the

GREEN BALANCE
A monitor image can look perfectly acceptable by itself. But compare this image with the others and it is clearly too green – the result of incorrect colour balance.

6000 K WHITE POINT
A white point of 6000 K (see Colour Temperature p108) is used widely in the graphic arts industry: it is rather warm, to simulate the appearance of white paper under bright domestic light (the usual environment for reading).

9300 K WHITE POINT
With a higher white point of 9300 K, the screen looks much bluer, and is closer to the setting used for domestic TV viewing. It is a setting suitable for working with text documents, but is not recommended for working with images which will be printed out.

GAMMA 2.2
The gamma setting of 2.2 is the standard for monitors running Windows. It produces a darker, apparently richer image than the lighter standard for Mac OS. Images adjusted to look right on this standard may look too light on Mac OS machines.

GAMMA 1.8
The Mac OS standard of 1.8 for the gamma setting produces a brighter image that appears a little less richly coloured than on Windows machines. Images adjusted to look right on this standard may look too dark on Windows machines.

relationship between the pixel values in your computer and the luminance of your monitor (the light energy it emits).

Finally, we adjust the white point: we decide whether we want whites to be slightly bluish, slightly yellowish or quite neutral. The right setting will depend on the use you intend to make of the images. For printing on glossy ink-jet printing paper, you need a white balance that is on the warm or yellowish side of neutral.

Colour management

The buzz of digital imaging these days, for very good reason, is colour management. It is one of the final frontiers of this technology: how to get hundreds of different monitors, printers, inks and papers as well as cameras and scanners to work together. The aim is simple enough: we want colours to be reliably accurate. But attaining this goal is amazingly tricky and elusive. Central to obtaining the colours you want is setting your monitor so that it shows what it is supposed to, in other words, it must be calibrated to a standard.

CAPTURING
digital images

Camera handling

It is safe to say that all digital cameras that you will come across are point-and-shoot: you need only turn it on, aim, press the button and everything else is taken care of. Focusing, exposure metering and setting, sensitivity level and even extra light if needed, can all be automatically set up for your picture.

Holding steady

The fact remains that the most frequent reason for spoiled pictures is lack of sharpness, which is most often caused by camera shake. If the camera moves during exposure – even if the exposure is brief – it causes the image to be less sharp than it could be. It may appear sharp in a small print, but if you want to enlarge the image, the unsharpness could become too visible.

It does not help us that modern cameras are so light and small. The disadvantage is that they move with each heartbeat and intake of breath. What is good for the pocket is bad news for photography.

UNSTEADY
Holding the camera away from you gives a good view of the LCD screen on the back of most cameras, but you cannot hold the camera very steadily. And it may be difficult to see the screen in detail if you cannot focus closely.

STEADY
You can use the direct-vision viewfinder – the viewfinder working with lenses – but the view is usually small. However, this braces the camera against your face, which helps to steady the camera.

Tips and hints

- If you buy a new camera for a special holiday trip or event, give yourself at least a week to learn how to use it, and to check that it is working properly.
- Squeeze or stroke down the shutter; do not push or jab it down.
- Practise holding the camera on its side to shoot portrait-format pictures: this hold is usually not comfortable, and you need to get used to it because it expands picture-making possibilities.

- In active picture-making situations (parties, exploring an ancient ruin) keep the camera on stand-by – on but not active – rather than turning it on and off all the time.
- Keep the front of the lens, the eyepiece and LCD screen spotlessly clean, using methods and materials recommended in the instruction booklet. Not only does that ensure that picture-quality is as good as the camera can give you, but also that you can see what you're doing.

Learning to use your camera

You can go a long way, enjoying yourself with rewarding photography all the while, without delving into camera techniques or the minutiae of your camera's abilities. But mastery of the little things can help you enjoy more and create better.

Camera quirks

No camera is perfect, not even models costing as much as a motorbike. Your camera may continue its zoom movements a little after you take your finger off the control. If so, a bit of practice with anticipating this defect is worthwhile.

If a feature that you use a lot is hidden deep in the camera menus, it is worth memorizing the keystrokes needed for the setting.

There may be a significant delay between pressing the shutter button and the exposure occurring. Practised anticipation can overcome this defect.

Getting the best results

The key to obtaining good results with digital imaging is simple: shoot a lot, and keep shooting. This is in fact the secret to professional working: they used to shoot dozens of rolls a day – their capacity to afford this practice is central to what distinguished them from amateurs. Working in digital imaging, of course, you have nothing like the running costs and, at your leisure, you can simply delete what you really do not need.

SHOOT LOTS
Bride and groom garlanding each other at a Hindu wedding. The moment is over in seconds: the only way to catch a key moment is to shoot lots – from start to finish – and hope.

SHOT SELECTED
A delicious moment of loving eye-contact is captured before the groom receives his garland. It was not at all clear until the pictures were reviewed that a usable image had been obtained.

Camera resolution

The maximum resolution of an image depends on your camera sensor and it, in turn, sets the upper limit on what you can do with the image – although the limits of a given image may well be much lower. Cameras allow you to reduce resolution – as if you had fewer pixels. This table helps you to relate resolution to usage.

Resolution	Usage
1 million pixels or less	Website or email, small images in newsletters
2–4 million pixels	Good quality prints up to A5, fair-quality to A4 and greater reproduction quality in books to A6.
4–6 million pixels	Good quality prints to A4. Reproduction quality in books to A5 or greater.
6–8 million pixels	Good quality prints to A3. Acceptable quality in books to A4.
8–11 million pixels	Excellent quality prints to A3 or greater. Reproduction quality in books to A4 or greater.

Simple and effective photo techniques

Learning about phototechnique is not about mastering technicalities like aperture, shutter time and focusing – although mastering photography is definitely based on an understanding these technicalities. Two simple techniques will quickly improve your photography immeasurably: getting closer and choosing your moment.

Get close

The most powerful way to improve your photography, especially of people, is to move closer, and closer – usually close enough to start to intrude on their personal space and – this is important – they are by corollary inside your personal space. It is often thought that all you have to do is to zoom in closer for the same effect. But then you do not enter into personal space, and you are not close at all.

GET CLOSE
Pictures of children grouped round and smiling for the camera are unavoidable, but you can at least get as close to them as possible. The cliché then has a chance to come alive and transcend its own predictability.

Choose your moment

When you have the luxury of time, use it wisely: wait for the shot to walk into your camera. It is as simple as that. The hard part is exercising patience. These storks live happily in the centre of a city. Like thousands of tourists you can be contented with a quick snap – or you can wait for something more interesting to happen. If you're lucky, you can wait comfortably, otherwise you just suffer for the sake of your art.

CHOOSE THE MOMENT
I photographed the storks over a period of an hour while having lunch, as we luckily found a restaurant that gave a good view of the storks, making over forty exposures in that time.

STORKS
This was the best of the bunch from an interrupted lunch, but spending more time would surely have provided far better pictures. Other tourists took pictures, of course, but seldom more than one or two.

Composition Primer

Composition describes, and sometimes prescribes, the way in which elements in a picture are disposed. The aim is to create at least a visually pleasing effect, and at best one which entrances the eye and entertains the mind. Composition is easy to teach. Yet many great photographs break the 'rules', and are possibly great for that reason.

The 'rules'

The rules are in fact a distillation of analyses of successful images. From observing that many images work because the main points of interest lie at the intersection of the thirds of the format, we obtain the rule that you should always place main objects at the thirds of the picture. Or we observe that placing the main subject in the exact centre of the image tends to lead to dull images – like product shots – and that leads to the rule forbidding such placement. None of us get inspired to be creative and artistic by being given a list of rules. What is more important is to learn how to see the underlying structure of the picture. Like an artist has a sense of where a person's bones and muscles are, and how they work, so photographers need a sense of the bones and muscles of the image. After that, we learn that what really matters is light – but that is trickier to learn.

COMPOSITION BEACH
Everything in its place and a place for everything: for one very brief moment, people, boats and children are positioned nicely separated, clearly visible and in a world of their own. The broad horizontal bands of the image define the distance and set out the space.

Skeleton

The skeleton of a picture is its underlying structure. The skeleton of an animal not only preserves the overall shape, but holds the parts together, and it is the same with the skeleton of an image. The skeleton can be symmetric: the parts arranged equally on either side of an axis running through the image. Or it could be like that of a snake: many repeating elements held together by a spine. Another type of skeleton is like that of a starfish, with radiating arms.

All these define atavistically, primally understood patterns. Little surprise, then, that they can be found in the images we make. If the underlying structure of a picture is strong where needed to take weight, and is balanced to hold symmetry, then we have a well-composed picture.

KIDS ON CHURCH STEPS

While this group of children, photographed at a church in Dubrovnik, Croatia, are arranged around the centre, there is activity on the edges too. The pattern of stairs helps to hold the image together, as does the centrally placed door.

BEACH COMPOSITION

The many and scattered elements of this picture are held together by the strong and repeated horizontal lines, and by the verticals of the parasol poles which link the horizontals.

Colour

The secret to composing with colour is to use a limited palette or range of colours. Scenes with a riot of different colours from across the whole spectrum are very tricky to organize and make convincing. However, one or two related colours work together and help hold the image together.

URBAN PATTERNS

A limited colour palette allows the eye to take in the strong shapes and strange spatial juxtapositions. In addition, this image uses the diagonal, which is one of the strongest and most effective 'skeletons' because lines that cut from one corner to another sweep the eye along the entirety.

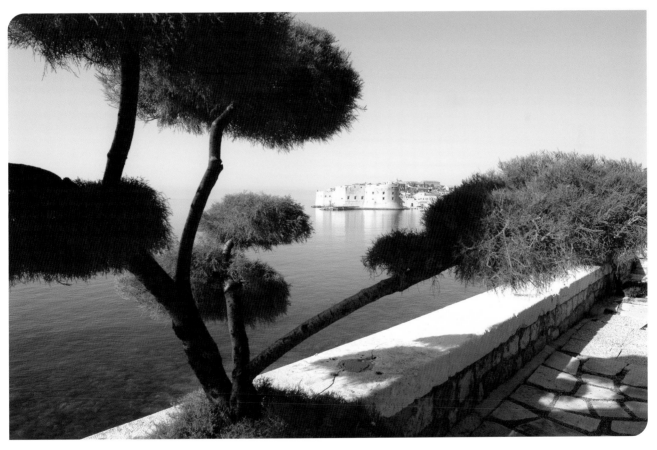

DUBROVNIK

In addition to its strong use of simple shapes and strongly diagonal lines, this picture uses very few colours indeed: a few greens and blues and a touch of orange from the distant town of Dubrovnik, Croatia.

Zooming – fabulous focal length

One of the most magical things that photography has done for our vision of the world was to give us the zoom lens – the ability to see a scene with greater or lesser magnification. There is no natural equivalent of the awesome zooming power of modern lenses. For broadcast TV, the zoom range can be as great as a 100X – the longest focal length is a hundred times greater than the shortest. For the rest of us, even a 10X zoom is very generous.

Changing size

The fundamental purpose of a zoom is to match the image magnification – whether it is larger or smaller than normal viewing with the unaided eye – with the subject matter. You can use the zoom to fit the image neatly into the frame of the viewfinder, so that it has just the right balance of space around the subject – not too little, not too much.

In general, digital cameras perform poorly when trying to take in a wide view; most cameras need to use a supplementary lens attached to the front, which is usually large and

DUBROVNIK UNFRAMED
From about the same position as the view (see left), a long focal length setting escapes from the archway to give an enlarged view of the town below. To preserve the very fine details of the roof tiles you need to be absolutely steady during exposure.

DUBROVNIK THROUGH ARCH
A fairly wide-angle view takes in an archway and hints at the view beyond. In some circumstances, you have limited freedom of movement, so a zoom is invaluable for giving you a variety of compositions.

adds to the camera's bulk. The telephoto effects – appearing to get closer to the subject by magnifying it – are, in contrast, a strength of digital cameras. The range can be extended even further by adding telephoto supplementary lenses. The down-side is that, as the image is magnified, so you also magnify any inadvertent movements you make during the exposure, so extreme magnification leads to great risk of camera-shake spoiling your images.

Stabilization and immobilization

A growing number of digital cameras that can set very long equivalent focal lengths (greater than 300mm), offer image stabilization: a mechanism that tries to keep the image sharp despite small movements you make. The alternative is to immobilize the camera by holding it close to your body, leaning on a support or – best of all – using a tripod.

Getting close

The digital camera is the first type of photographic equipment that is at home working at very close distances. This is a happy development, since the most rewarding field of photography is the close-up: it reveals details and uncommonly attractive things that are normally ignored. You need to focus carefully

Many digital cameras offer a feature called digital zoom. This comes into play when the zoom is at its longest setting. It crops the central portion of the image, then enlarges it to fill the frame. By taking a small portion of the image to fill the frame, it creates a zoom effect. Naturally, the greater the zoom effect, the poorer the result. Moderate digital zoom has its uses, but anything greater than about 2X starts to be worse than useless.

and hold the camera steady. You will also find it easier to obtain good results from flat or nearly two-dimensional subjects.

MOTH
A moth resting on a window pane is easy to approach. Because light levels were very low, the image is quite grainy from the high sensitivity used.

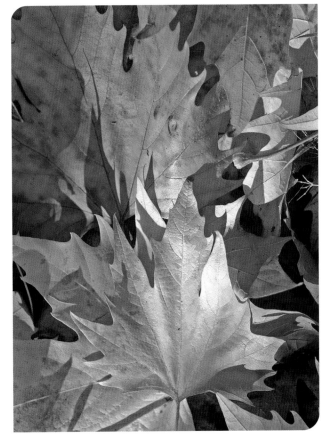

LEAVES
Getting close to nature, you can enjoy delightful details and visual treats that others would pass by. Focus accuracy is critical, since the unsharpness will spoil the fine details and shape of your subject.

Working a subject

The zoom action is not, however, a substitute for moving yourself. Old-timer photographers used to say the best zoom is your feet, and there is much wisdom in that. Remember that zooming does not change perspective: you simply see a different portion of the overall scene. Combine the power of the zoom with the power of your feet and you have the means to work a subject: explore its angles to obtain the best shot or a series of usable ones.

1

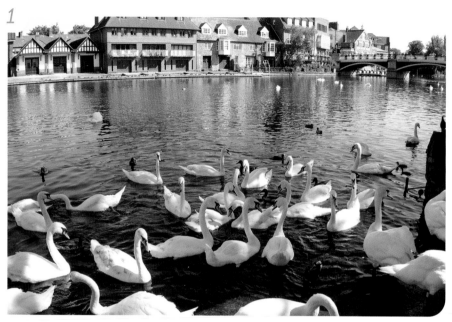

2

SWANS ESTABLISHING HORIZONTAL
Perhaps the most accessible and obvious shot to take is a wide, establishing view that takes in the whole scene and provides a context for the main subject. Notice the barrel distortion typical of a wide-angle attachment.

SWANS ESTABLISHING VERTICAL
A portrait format view of the same scene is marginally more interesting because the sense of space leading from the swans, across the river to the houses and sky is better conveyed by the vertical than with a horizontal view.

5

SWANS AND GEESE
Tired of the swans, we look up and notice a flotilla of geese heading our way to join in the feeding. For a moment they unconsciously take up a swimming pattern similar to their flying pattern, probably for similar reasons.

Perspective

Perspective changes require you to move, to bend down or raise yourself to a higher view. These changes in perspective are all about changing your relationship with the subject, which thereby charges your images with the energy of that relationship. In this series of swans gathering on the River Thames near Windsor, England there was not much room for movement. Even so, by combining small changes in position, such as shooting from lower down, with different focal lengths, it was possible to obtain a variety of shots showing different aspects of the swans and their relationship with other birds on the river.

3

4

SWANS AND DUCK

A change from wide-angle to longer focal length brings us closer to the melée of birds on the water, but it takes Sisyphean patience to snap a view that does not awkwardly cut off one or more birds.

SWAN PROFILES

A longer focal length still means we deliberately cut to patterns and cropped views in search of a pattern of shapes or forms that pass in a split moment from jumble to significance – or at least a visually attractive arrangement.

6

SWANS – BEST OF BUNCH

But the best shot came from leaning forward and pushing the camera as far as I dared into the group. It is for this kind of photography that the LCD panel on the back of digital cameras is made: you can check composition with the camera at arm's length.

Trouble-shoot: common photo faults

Fault

Colours do not look right, especially in shots taken indoors.

Explanation

Digital cameras need to work out what is the actual colour of white light before it can calculate the values of all the other colours accurately. If the white light – that is, the brightest – is too strongly coloured (in domestic lighting white is quite strongly reddish-yellow) then it will set all other colours to that 'white'. As a result, colours appear too red.

Strategy

If accurate colour matters to you, use extra lights indoors. In most circumstances, the automatic corrections work well but are increasingly unable to correct as the brightest light moves away from being neutral. You can also make corrections to the balance after the shot is made (see pp72 and 108–9).

DOMESTIC LIGHTING
Under normal room lamps, the image has a good structure and lots of interesting lines but the colours are much too yellow-red, and no neutral colour – like a true grey or white – is visible. The corrected image is shown on page 108/9.

Fault	Camera appears not to focus properly.	Buildings appear to lean backwards.
Explanation	Autofocus mechanisms which rely on shining an invisible beam of infrared light on the subject will be upset if you try to focus through glass or if there are many obstacles in the way (if you are looking through railings, for instance). Other mechanisms search for the nearest object and focus on that, as a default. Some systems are confused if you point the camera at a very bright subject (reflection of the sun on water, for instance) or if the subject is very plain, such as a smooth wall, or if it is fast-moving, such as rough water.	Anything with straight, parallel sides will appear to lean backwards or recede in one direction whenever the camera is pointed at an angle to the sides. In the case of a building, the camera is often pointed upwards to take in the full height of the building. This means that the bottom of the camera is fractionally nearer the building than the top of the camera. Objects that are further away appear smaller, so the top of the building looks smaller, and thus appears to be leaning back.
Strategy	Learn the limitations of your camera and try to focus on something with which it can work that is about the same distance away as your proper subject. Many cameras allow you to hold the focus setting with a half-pressure on the shutter button, so you can focus on a substitute or if your subject is off-centre, then you can re-compose the picture.	Try to hold the camera level. For this you will need the lens set to the widest (smallest focal length) to take in as much as possible. It will help to hold the camera to portrait format to catch as much height as possible. The result of holding the camera level will be too much foreground, but you can remove that later (see p101).

GIRL ON RED CARPET
Because the child in red is off-centre in the image, the focusing mechanism could well focus on the people in the distance. This would ruin the shot. So focus was taken of the little girl, then the shot was re-composed.

CONVERGING PARALLELS
The opposite to buildings leaning backwards when you photograph them by pointing the camera up will occur when you point the camera downward. Here, skyscrapers of Hong Kong appear to be radiating outward like flower petals, to vertiginous effect.

Exposure: what is right and how to get it right

The hallmark of a good photographer is consistency of exposure. Interestingly, it is the area in which automated processes remain at their weakest.

NORMAL EXPOSURE
This image shows a good range of tones and detail throughout the image: averaged out, the bright areas combined come to a grey about half-way between black and white.

LESS EXPOSURE
A darker image brings out shapes, the sky and it intensifies colours. It is no less acceptable than the 'correct' exposure. Not all images will survive so much reduction in exposure: this image does because of its wide, but evenly distributed, range of tones.

EXTRA EXPOSURE
With more exposure than 'correct', the image takes on a different look altogether. It is more airy, the sky looks less threatening and the mood is much more summery, while colours are less intense than in the other versions.

What is exposure?

Exposure is the combination of the duration of time that a film or sensor is exposed to light, and the intensity of the exposing light. With a digital camera set fully to automatic, another factor comes into play: the sensitivity of the sensor. If light is very bright, the sensor is lowered in sensitivity to enable usable shutter and aperture settings. If light levels are very low, the sensor is made more sensitive: this can help reduce dependence on flash.

Right and wrong exposure

The right exposure is the exposure that you want for the image. There is a scientifically correct exposure for any situation, but that matters only to sad old technophiles like me. What is important is that sometimes the picture is better if it's darker than 'correct'; at times it is better if brighter.

It is important for you to understand what the camera is trying to do when it sets exposure: it aims to expose the picture so that its overall, or averaged, brightness is half-way between white and black. An overexposed picture looks too white, an underexposed image looks too close to black.

It may seem that one of the advantages of digital imaging is that you can correct errors. Indeed you can, but there is nothing better than getting it right in the first place. You save work, of course, but more importantly, the best image quality comes from properly exposed digital images – just like film.

Secrets of perfect exposure

The secret for obtaining perfect exposures is irritatingly simple, yet rather demanding. It is to visualize the result you want. This is rather like being good at sports or music. You cannot hit the ball right unless you know where you want it to go; you cannot sing the right note without 'hearing' beforehand which note you want.

Experience grows

The best way to learn to visualize the effect is to compare what you wanted in the image with the result. You will discover that very bright, white scenes like beaches and snow tend to come out darker than you'd like. And subjects with dark colours, like black cats or dogs and dark foliage, tend to come out too light. In addition, exposure tends to be easier when the light is behind you, and trickier when the camera faces the light.

Modern cameras can analyze the scene to make a good stab at getting the right exposure, but in the end it is up to you. Most modern cameras allow you to override the auto-exposure. If you expect the shot to come out too dark, you need to manually increase the exposure. Or decrease the exposure if you want the image darker. If in doubt, it is best to take two or three shots with extra, less and 'correct' exposure. This is called bracketing the exposure or, to the more honest of photographers, it is known as 'hedging the bet'. Start by setting over- or underexposure by one-stop steps: plus one stop for extra exposure, minus one stop for less. Use the half or third of a stop increments when you need the precision.

SNOW – AUTO-EXPOSURE
Straight out of the camera, this view is rather underexposed: the snow is not brilliant white and the figures appear too dark. The automatic exposure system did give more exposure than it normally would, but it is still not sufficient.

SNOW – EXTRA EXPOSURE
With extra exposure dialled in, the snow sparkles and you can make out colours in the figures. Note that the camera may warn you that you are overexposed, but you need to ignore that as the image needs the extra light to look correct.

Using flash – or not

The best flash-exposed images are those which do not look as if they had been exposed by a flash. The aim is for the flash to do its job, but not to be spotted doing it. The secret is in making good use of such light as is available.

When you have to

Ideally, flash is supplementary lighting: you use it to add to what is available. Nonetheless, it is most used as the main source of light – usually when what is available is not useful. The birthday party in a club, barbecues in the evening, and many home interior scenes are all bereft of decent lighting. A camera flash seems to be the ideal solution. But think of a romantic candle-lit evening: you would hesitate to use a flash to illuminate this scene: the results are harsh, the lighting is uneven and, to complete the indictment, the flash ruins the atmosphere.

Balancing

The key to effective use of flash is to balance it with the available light. It is not a technique for the faint-hearted and takes a good deal of practice. Fortunately, many of the intermediate and advanced level cameras can give balanced flash exposures automatically. Even so, as can be seen in the image below left it is harder to remove the unevenness of lighting.

The best advice is to avoid using flash if you can. And remember that the flash built into the camera has a range that is barely more than two or three metres. So it is completely useless for use in theatres, pop concerts or night-time views.

PARTY NO FLASH
With all the dancing going on, at celebrations in Tashkent, Uzbekistan, the exposure needed for the relatively low light indoors is not short enough to stop the action. Even the relatively slow movements of a man leaning forward appear blurred.

PARTY FLASH
With an on-camera flash exposure, we obtain sharp action pictures, but at the expense of uneven lighting: the near objects on the table are much brighter than those in the distant part of the room.

BOUNCE FLASH
When the flash is turned to a wall, which reflects the light back to the subject, a soft and diffused lighting is achieved. Good balance with existing light helps create acceptable lighting.

Exposure effects

We know now that correct exposure depends entirely on what you want the image to look like; but we can take it further. We can expose just for the highlights – the brightest areas – or we can expose wholly for the shadows.

Silhouette

If you expose for the brightest part of the image – and get that down to near mid-grey – you do not have to be a professional photographer to know that the shadow areas will become completely black – the silhouette. With the right kind of subject, the silhouette effect is striking and effective: naturally it works best for clear shapes and forms. Aim the camera at the brightest point and hold the exposure reading (press a special button or half-pressure on the shutter button), then re-compose.

SILHOUETTE
When photographing against the light, exposure is controlled by the sky's brightness. The reduced exposure brings colour into the sky, but the shadow side of the trees become completely black. Which suits us: we want the spindly shapes to come to the fore.

HIGH-KEY BABY
By taking the exposure from the dark side of the baby's head, and increasing it by another two stops, a washed-out effect with pale colours was created. A normal exposure would be entirely acceptable, but this version is better.

High-key

The opposite of exposing for the highlights is to set the exposure by the darkest parts: if you do that, there will be no real shadows since the darkest parts will become mid-grey. This is the high-key picture. It pushes all the bright tones even higher, so the image appears very bright, white and low in contrast. This is ideal for many portraits, fashion and wedding photography. The technique is the same as for silhouettes, except that you take the reading from the darker parts of the image, then, as before, hold the reading and re-compose the shot.

Getting the colour right

The secret of colour photography lies in exposure control: get the exposure right, and the colours follow. But making the colours visually interesting is trickier: you have to get the light right. The exposure may be correct, but the subject can be lit in a number of ways. Here the secret is that if the light looks great, it almost always is – we have a basic instinct for it.

Side or in front

The most interesting light is usually the most difficult to work with: light that comes from in front of you – from any angle between sideways on to right in front. Light coming into the lens can cause flare or glare: stray light that interferes with the image. Light from the side delivers interesting shadows, but makes exposure control tricky. The best advice is to bracket (make at least three shots, exposing a little more than correct, a little less and at the correct setting). It may seem like cheating, but it is what professionals do, so don't be ashamed.

In bright situations you will find a large difference between the brightest parts of the image and the darkest. In that case it is better to err on the side of underexposure. This tends to improve the saturation or richness of colours. On the whole, viewers prefer dark, featureless shadows to bright, featureless highlights.

Colour balance

Once the preoccupation of photographers using colour film, colour balance – ensuring that colours are accurately recorded, with neutral greys, whites and blacks – is less of a problem with digital imaging.

If the illuminating colour is not white but some other colour – commonly orange from house lamps – then the colour balance is upset. However, given a high level of brightness, modern systems can cope with a wide range of illuminating colours. Generally, you can make any small adjustments needed when you undertake image manipulation. If your image is printed by a laboratory, colour balancing adjustments should be part of the service.

HINDU BRIDE AND GROOM BACKLIT
Perfect natural lighting shows off the brilliant Indian wedding colours: light from one side and in front, is supplemented by light reflected off the ground.

Getting the timing right

The phrase 'the decisive moment' is perhaps the most famous in photography, inspiring and shaping the work of millions of photographers worldwide, from photography college to evening class. But in the era of digital imaging, our practical concern has to be with the instant just before the decisive moment.

Shutter lag

All digital cameras use what amounts to a rather powerful computer to run the internal operations. When you turn it on, it has to boot up like any other computer, which consists of checking that everything is present, correct and then loading instructions for the day. And, like a desk-top computer, some are faster than others. Some cameras can easily take as long as three or four seconds to start up, others as short as one or two. When you press the shutter button, final checking and adjustments are needed by the system before it will take the picture: this causes a delay – the shutter lag – before the shot is actually made.

All but the costliest or newest cameras suffer from a noticeable delay. This means you need to anticipate the action in order to be able to catch it at the right time. You have to learn to press the shutter button just before the decisive moment – how much before depends on your camera and the quality of your motor coordination.

Watch and wait

The best advice is to watch, and to wait. Only then can you be ready. Keep the camera powered on: it may go to sleep on stand-by after a minute or two. Most cameras wake up more quickly from stand-by, so don't turn it off completely.

We have all experienced the frustration of seeing something develop before our eyes and were so entranced by it that we forgot – until too late – to ready the camera (and professionals will be the first to admit to this). The only cure for this is constant vigilance. The side-benefit of this is that you see far more of life than the average person, your experience of holidays and outings will deepen and be enriched.

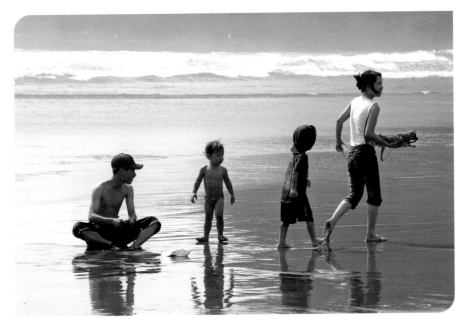

KAREKARE BEACH
Perfect timing from the photographer catches these children in an order and precision of team movement that would have surprised them had they known. It is a lovely moment caught by lying in wait in an intelligently predictive frame of mind.

TRANSFERRING
digital images

The magic of connections

Talk to any computer engineer about inter-connections between electronic equipment and he or she will bend your ear about how no-one can agree on anything: it is information technology's equivalent of the Tower of Babel. Frankly, it is a minor miracle that any piece of equipment can communicate with another: 'standards' are not enforceable, and engineers will always think they know better than the international committees. The up-shot is this: when you plug a camera or printer or other device into a computer and it doesn't work, then it is almost certainly not your fault.

Setting up

It may not be necessary to connect your camera to your computer if the only task is to transfer pictures from the removable memory to the computer. But some more advanced cameras need to be connected to the computer if you wish to change certain settings or to take pictures directly from the computer (shooting pictures by controlling the camera from the computer when working in a studio). Even if you remove the memory card from the camera, you still need to connect a card reader to the computer. For a connection to work, the leads and sockets must be compatible, and the software used by the computer to control the behaviour of the input and output must be compatible – with both devices.

Keeping up to date

If you have followed the instructions, done everything in the right order (read the instructions before plugging in or turning anything on), but it still does not work, the most likely problem is the software. You may be using an older operating system on your computer than the software expects, or it may be more recent than expected. There may be conflicts between equipment making similar calls to the input/output port (for instance, you may be using a digital camera as well as a scanner, which both call on the USB socket). The solution is to look for the website of the equipment manufacturer and download the latest driver – the software which controls connections.

Pursuing leads

In digital imaging, the leads or inter-connects you will encounter most often are USB (Universal Serial Bus) and FireWire (also known as IEEE 1394 or iLink). They are simple to use in that, with the majority of accessories, you need only plug in an item for it to work.

USB is widely used for connecting cameras, memory card readers and CD writers to computers, and printers to computers. It comes in two versions, plain USB and USB 2.0, the latter providing greater data transfer speeds.

Firewire is used to connect hard-disk drives, CD and DVD writers, higher-specification digital cameras and DV camcorders to computers. In its first version it is faster than USB, but is a little slower than USB 2.0 (400 Mbits/sec compared to 480 Mbits/sec).

Different ends

This simple picture is ruined by the fact that each type of lead can sport different connectors at either or both ends. This is to allow for larger-sized plugs – for easy fitting and strength – while smaller plugs are used where strength of socket is not important, but compact design is. At the same time the plug or jack can be a protruding socket or a receiving type (male or female). As a result, if you need to purchase a lead, ensure you obtain the specification from your instruction books for both ends before ordering.

PLUG ENDS
Only a selection of the varieties of FireWire and USB plugs are shown here. It can help to label the leads with their home, and also which way up they fit into your accessory.

Direct connection to printers

If your main interest is in making prints from your pictures – it was, after all, essentially all that most photographers ever did – then you do not need a computer at all. One way is to ensure that your camera is PictBridge-compliant and that you connect it to a similarly specified printer. You can 'order' prints from either the camera's menu selection or from the printer. But you do not need to be limited to the PictBridge protocol. You can purchase a printer that prints direct from memory card: insert the card, the printer reads the data and you can control printing from the card.

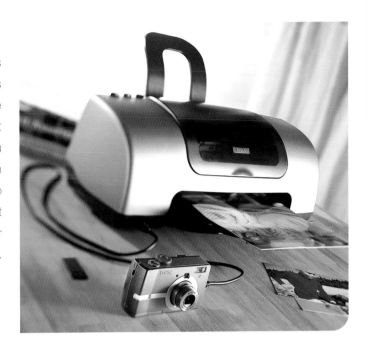

EPSON DIRECT PRINTING
The majority of new desk-top printers can also print direct from camera: look for the signs of PictBridge compliance.

Wireless connections

A feature that is growing in popularity is wireless connectivity. Working either through ultra-high frequency radio transmission or by infrared light (like your TV or hi-fi remote control), you do not need to plug anything in. But you do need appliances that speak the same language, as it were, and will recognize each other. In some cases it can be as simple as pointing your mobile phone camera at a printer or lap-top computer with an infrared port and they will automatically recognize each other. Working with radio, you will need to establish network-like connections: this is to ensure security of your systems.

Dealing with problems

- All modern leads are keyed (they can go in only one way) work out which way it is before attempting connection.
- Never force a lead into its socket: if it doesn't want to go in, then it probably doesn't fit because it is the wrong one, or it has been damaged.
- Purchase good-quality leads: the leads packed with bargain equipment is likely to be bargain quality.
- Never pull out an inter-connect lead while a light on the equipment is flickering or indicating activity.

- The order in which you plug in your equipment can be important: there could be a difference between plugging an interconnect to a card-reader before plugging it into a computer; and plugging the lead into the computer before connecting to the card-reader.
- When plugging in a power lead, always plug the dead lead into the equipment first, before connecting to the power supply.

Trouble-shooting: making the connection

Fault	You have installed the software and plugged in everything, but the accessory is not recognized by the computer or it says that nothing is connected.	You have installed the software, but the computer keeps crashing. Or software freezes in the middle of working. Or some software refuse to start.
Explanation	An attempt to get Windows to set up the equipment may have failed. The computer may need to recognize the new software and the settings that the software needs to make: this usually occurs when the computer is restarted. Or you may need to make extra settings to ensure the computer recognizes or is set up for your accessory.	Your new software is in conflict with your existing set-up. It may not be the application itself, but small extras that cause the conflicts. This can include USB drivers or small pieces of software designed to make your accessory work with the software or computer.
Strategy	Close down the computer, turn off the accessory, restart the computer and turn on the accessory. When boot-up is complete, try again. If this fails on Windows computers, ask the operating system to check for connected equipment and to set it up for you. If this fails, it is quite likely that you need to up-date some software. Visit the website of your operating system and your accessory for the latest up-dates. Note that if your version of Windows is several years old, it may not be possible to find suitable up-dating software; you will have to up-date Windows itself.	Isolate the problem first. Establish whether it is the new piece of software that is the problem by uninstalling to see if the crashing recurs. But the latest installation may not be the real problem: if it is the latest version available, it may conflict with an older version of something that you installed previously. In that case, it may be the older software that needs to be up-dated by downloading an up-dater from the manufacturer's website.

DUNHUANG
Sand-dunes — such as this giant in Xinjiang Province, China — beaches, dusty areas and highly humid conditions are all enemies of digital imaging. Avoid changing cards outside or any exposure to sand and dust.

Using memory cards

Memory cards are also referred to as digital film. Their steady improvement has helped power the growth of digital imaging. You record all your images onto memory cards, so their speed and reliability are paramount to digital imaging. Fortunately, modern cards are very reliable and most of them are sturdy, collapsing only under deliberate abuse.

Variety of cards

The types and formats of cards increases steadily. The tacky motivations of patent avoidance, search for market niches and sheer proprietorial greed generate confusion where they claim to offer greater choice. The main types of cards in use employ similar flash memory technology offering the same key benefit: data is held without the need for power.

The most widely used card is the CompactFlash: small, sturdy and available in large capacities. It is the thickest card and therefore easiest for card readers to offer adaptors for the thinner formats. These are the SecureDigital – very small – and the xD – even smaller – formats. The SmartMedia offers limited capacity and is falling out of use: avoid cameras using it.

CF CARD
A modest capacity card (less than 128MB) is adequate in cameras with around 3 megapixel counts. And they are least expensive.

SECURE DIGITAL CARD
Identical in size and appearance to MultiMedia Cards, the SD card is in wide use and capable of good speeds.

CF CARD 4GB
A very high-capacity card like this will last for a very long holiday or very exciting safari tour. However, you are keeping all your data in one very small, very easy-to-lose item whose total reliability cannot be guaranteed.

XD CARD
Newest and smallest of them all, the xD card is growing in popularity and is capable of very high capacities despite its small dimensions.

MEMORY STICK
This design of card is used by a limited range of cameras, and has compatibility problems with older versions.

Tips and hints

- Do not open the card door while the camera is writing to it, usually indicated by a small flashing light.
- If the card appears not to be registered, remove it and then slide it in and out a few times: this often helps to clean the contacts.

- Cards will survive being dropped, but not extreme heat or water.
- If you use more than one card, place it back in its case upside down when it is full, so you know which is 'exposed' and which not.

Storage options

Though lightweight and of handy dimensions, memory cards are, of all electronic media, by far the most costly way of storing information and therefore not the best option for permanent storage of your images.

CD and DVD

CDs and DVDs are, by a long chalk, the lowest per unit cost way to store data. Furthermore, any modern computer can play CDs, while the majority of modern computers will also play DVDs. They are fairly stable, although doubts about their long-term stability have emerged. Their main disadvantage is that they are slow to write (accept and record the data) and slow to read.

The low cost of CDs – comparable to a soft drink per disc in many countries – means there is no excuse for not backing up (making a spare copy) of your images. Do not join the growing numbers of digital photographers who have lost hundreds of images because they failed to make the effort to back-up, until one day their computer's hard-disk crashed and everything was irretrievably lost.

DVDs and CDs exploit essentially the same technology, the main difference being that DVDs can hold up to about 5GB (GigaByte) of data, depending on type, while CDs hold about 700MB (MegaByte) – or under three-quarters of a GigaByte.

If you become a heavy producer of digital images, it is worth considering special drives that copy from memory cards direct to CDs or DVDs without a computer.

LACIE DVD
DVD writers are more versatile than CD writers because they can write both CDs and DVDs. While modern writers are much faster than earlier models, they are still slow compared to hard-disk drives.

ALERA PHOTO COPY
A growing range of CD writers allow you to write data directly from your memory card to CDs. Models such as this from Alera allow you to copy several small-capacity cards to one CD or span one large card across two or more CDs.

Tips and hints

- Copy all of your pictures onto CDs or DVDs at regular intervals.
- Keep your back-up CDs at a different location from your computer if possible – to prevent the same disaster striking both.
- Close the session of your CD recording (locked against being written to further). This tends to increase compatibility of CD to machines other than your own: a closed session disc is more likely to work on more machines than one that isn't; CDs that do not read on a machine are more likely to be open session.
- It is not necessary to purchase the most expensive CDs, but do not buy the cheapest.
- Name your discs by alphanumeric code and date, not by subject – as your collection grows, keeping track of discs by subject becomes very cumbersome.

Picture drives

We have already considered using supplementary hard-disk drives for the computer. A rapidly growing category of accessory is the picture drive, which is designed to file away thousands of images onto a small battery-powered hard-disk. This is the best solution, so far, for unloading pictures from full memory cards so that you can continue to shoot without having to delete pictures to make more space. They also save having to carry many cards, which work out much more expensive than using a picture drive.

On these machines you slip in your memory card and press a button or two to transfer files from the memory card to the drive. Some machines require cards to be on adaptors before they can be read, others offer several different slots to take all existing cards.

The most useful machines, but also the costliest, have a small LCD screen for you to review images. But beware that using the LCD screen quickly runs down the battery. The majority of machines are run from rechargeable internal batteries. Some units offer verification of the copy to ensure there are no differences between the files on the drive and the originals – a reassuring feature. Others allow you to change file names and do other computer house-keeping tasks. More economical models have a simple screen showing only file names and status symbols. The majority of machines can be connected to a domestic TV so that pictures can be reviewed on a large screen.

NIKON COOLWALKER
Running the middle course, the most common design, such as this model from Nikon, uses a screen that is neither large nor small. This model is well made and stylish, but optimized for Nikon formats.

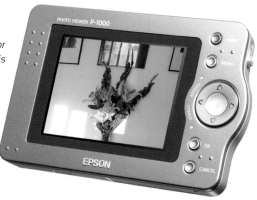

EPSON PHOTOVIEWER
A few picture drives opt for large screens, such as this model from Epson. Some versions will even play movies. Costs, both for purchase and in battery consumption, are generally higher than for other designs.

NIXVUE VISTA
Designs such as this Nixvue Vista picture drive use a small LCD screen to conserve power, relying on zooming and scrolling of the image for checking the image. Capacities of up to 60GB allow for large picture collections.

Managing the files and keeping track

A comment heard frequently from people returning from a holiday or trip goes along the lines of 'I used to come back with maybe four or five rolls of film; but now I have four or five hundred shots'. There has been an explosion in the number of photos taken throughout the world, and it can all be put down to the extremely low per-picture cost of taking pictures.

Policy decisions

Policies, storage and cataloguing are concepts foreign to the now nostalgically touching habit of leaving everything to the shoe-box system. You need to decide whether you will delete image files you do not want, or keep everything. If pictures are solely a source of amusement, and you do not want them to take over your life and computer, then your policy is clear: delete anything that is unsuccessful, technically poor or just plain dull. At the other extreme, some of us will never want to delete anything, ever. You never know what use a shot may have, however dull it appears.

You may institute a policy of keeping pictures of, say, your children and loved ones whether they are technically or artistically outstanding or not. Anything else of passing interest can be deleted.

FOTOSTATION THUMBNAILS
Fotoware FotoStation is a very rapid and flexible image management application. It can display thumbnails of folders in almost the same time as the operating system takes to list the files.

FOTOSTATION BIG THUMBNAILS
Fotoware FotoStation can change its view from showing small thumbnails to one with large thumbnail views. Other features such as previewing of files are not as flexible as with Portfolio.

Tips and hints

- For files and folders, use names that mean something, rather than code numbers.
- If renaming a whole lot of files is too difficult for you, put related images into a folder with a meaningful name, e.g. Emily b-day 2005.

- Make copies of any images that really stand out as soon as you recognize their value.
- Avoid the temptation to show a large number of thumbnails at once unless you have a powerful computer with a lot of RAM installed.

PORTFOLIO THUMBNAILS

Extensis Portfolio takes a more structured approach compared to FotoStation: images cannot be previewed without first undertaking a lengthy cataloguing process. And catalogues of large folders of pictures can themselves take up a lot of hard-disk space.

Cataloguing collections

Whatever policy towards deletion you adopt, you will eventually need a way to catalogue your pictures. You may be able to find them while they number a few hundred, but when the population reaches a thousand and more, you need help.

Picture management, sometimes called media (also digital) asset management, is a rapidly growing area of software development. At least the software will present a collection of thumbnail views of your images through which you can scroll. At best, and if you can put in the work needed, you can give keywords to every picture, then locate them by keywords. Some software can re-name dozens of pictures at a time: instead of the impenetrable DSCN00234.jpg that may be given by the camera, you could turn it into a more useful date-plus-number: 2005-01-01-234.jpg or location: spain2334.jpg.

PORTFOLIO THUMBNAILS MOUNTS

Portfolio offers differing styles of customization of the interface: this helps with viewing images. It also offers useful tools for moving pictures around, and powerful methods of renaming files.

Apple Macintosh users are fortunate in that the powerful and easy-to-use iPhoto is supplied with new machines. This software recognizes when you plug in a camera or card and offers to download them and cat-alogue them. Another popular application, for Windows only, is ACDSee. However, it is dwarfed by Adobe Photo Album, a well-crafted, powerful application that is also Windows-only. One application available in both Mac OS and Windows is iView Media.

For larger collections and more compli-cated needs – for both Windows and Mac OS – the best applications are Extensis Portfolio and Fotoware FotoStation. Both have their strengths and weaknesses, but neither is likely to disappoint.

PHOTOSHOP ELEMENTS BROWSER

Many image manipulation applications such as Photoshop Elements include browsers which help you locate files. But their ability to find images or house-keep with file names is limited.

SHARING
digital images

The range of opportunities

The effect of the Internet on the consumption of pictures is the most interesting aspect of digital imaging. You can send pictures from Europe to friends deep in Central Asia; I can send pictures from England to my daughter in Hong Kong for her to work on and place on a website hosted in the USA. Dozens of people located anywhere in the world can view your images – and all at once. If you have a suitable set-up, the numbers can rise to thousands of simultaneous viewings.

The central notion

At the centre of this potential are two very simple conditions, compliance with which enables the entire system to work. The first is that everyone uses the JPEG (jay-peg) file format, so that all software which needs to handle them will know what to do with them. The other is that image files are kept as small as possible; compatible with the purpose for which they are being used.

JPEG is a species of compressed file: the data is reduced so that it takes up less space. The method is very effective but also reduces image quality. However, much quality in an image is redundant – like the loquacious person who needs three sentences to say 'No'. JPEG exploits this redundancy and it is up to us how much quality we are prepared to forego.

General guidelines

With the proviso that everything depends on your threshold for low quality, here are some suggestions: Avoid the lowest quality settings in JPEG; nor is it necessary to use the highest settings unless you need the quality to off-set the overhead of large files.

ORIGINAL
A 3-megapixel portrait will give reproduction quality up to about 15cm (6 in). The original data from the 3-megapixel image is 9MB, but can be compressed to different extents depending on method used and the quality loss that can be accepted.

LOW-QUALITY JPEG
At the lowest quality and highest compression ratio, the image will show many defects: patchy tones, break-up of detail and disfiguring blocks of pixels. However, when the picture is kept small, these defects are not apparent, and the photograph appears to be of the same quality as the larger file.

HIGH-QUALITY JPEG
At the highest quality, but lowest compression, we have a file size of 0.84MB (which takes 150sec to download on a normal phone line, compared to the 8sec of the 46K file). However, it preserves all the quality of the original and only an expert, who knows how to dig out the defects, would be able to spot this from the original, uncompressed file.

Small images are usually adequate for email: try between 50 and 100 pixels wide, or compressed file sizes of around 15–20K. For more detailed pictures, size them to a maximum of 480 pixels at the maximum dimension: this gives an image that will compress to around 40K at medium quality.

Email etiquette

The main point of etiquette in emails is not to send anyone more than they expect, want or need. That is why spam – pointless, ridiculous or pushy emails – is so objectionable. Close second to spam is the emailer who sends you 5MB of pictures or movies which you do not need nor want. This takes a long time for most Internet users to download. It holds up the delivery of more important emails, fills up your inbox with unwanted material and, worse, can crash the connection. Some email accounts, particularly the free ones, forbid the sending of large files. If you wish to send many pictures (your wedding photos to family on the other side of the globe, for instance), check whether that will be welcome. Or send very small, compact images: if anyone needs any full-size images, they can ask you for the high-resolution versions. If the compressed files are larger than 0.5MB, send them one by one, in separate emails.

Sending pictures by email

An email is a piece of data which can be formatted as words or in a form which can be read like a web page. When you send an email, you send a small packet of data that is translated and displayed by your email software. A picture is essentially just an addition to that package of information: it can be attached – just another data file that rides along with the email – or it can be incorporated and become part of the email.

The standard practice used to be to attach images, because email clients (or the software that reads emails) could not interpret pictures. The attached pictures had to be opened in software which would know what to do with the data. But now email clients can display pictures, so it may be easier to incorporate the image with the message. For this to work, the software needs to be set to read HTML (hyper-text mark-up language).

HTML EMAIL
Tiny image files can be dropped into an HTML email message, so the pictures become part of the message. It is a simple and effective way to communicate with pictures. Some software can display the images in the email even if they are attached, but these are appended to the end of the message.

Editing your pictures for the web

For some, the chance to display pictures on the World Wide Web is an unadulterated vanity, a chance to extend one's Warholian fame beyond its allotted 15 minutes. You can display your images for the world to rush to your web portal and admire. Well, little harm is done – and sometimes a fair deal of good. The unprecedented access to images, independent of distance, time and creed, means that if you want an honest view of a tourist resort, you may well find it in someone's holiday snaps. If you want to know what the Siberian Marmot (a ground-squirrel) looks like and why it's different from the Caucasian, you may well be able to find a picture of both on the web.

Picture-editing

The issue is not whether you join one of the numerous picture-sharing websites that exist – or construct your own website (see pp92–5) – but how you will distinguish yourself from the thousands of photographers on display. A survey of pictures shows that the main problem is not in people's skill as photographers, but in their lack of skill as editors of pictures. We look now at some of the ways in which you can ensure that you put on your best images – and, indeed, how to select them. The first guideline to remember is a tough one, but applying it (and surviving the pain) can only improve your photography. It is this: if you have any doubt, then it's out. Reject any image you're not sure about: love what you keep, and keep what you love.

Next, and related: be ruthless with your technical control. If the picture is unsharp for any reason, if exposure is irremediably wrong, drop it. There is nothing wrong with keeping your standards low and allowing yourself to display any picture – unless you are trying to improve your photography. Then, if the picture is flawed, forget it. Promise yourself to do better next time.

Legal issues

The moment your pictures go public, you enter a different legal world. It is one in which you have responsibilities to those featured in your images, to those who make arrangements for the dissemination of your photos, and even to those who view your pictures. It is obvious you should not place any pictures which break the law in your own country. But then you need to know the law in your country. Pictures of your children playing naked on a beach could have police knocking on your door in many countries, but be ignored in others. And it is not so clear what happens if your pictures are viewed abroad. Your snaps of military aircraft flying over your holiday beach could possibly land you in jail the next time you return to the country. And if anyone featured in your photographs lacks the humour to appreciate the witty caption you penned, the legal fees for getting you out of trouble will also lack humour. In short, if in doubt, seek legal or knowledgeable advice.

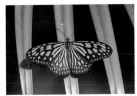

Story-telling

A collection of pictures can be arranged in a confusing way or so that one picture flows to the next, or linked in a way that tells a story. You want to reach other people, and for that a clear purpose helps to give structure to your collection.

For example, your holiday pictures may be taken at different times of the day in different places. If left in chronological order of shooting, a sunset could be followed by another sunset, then an afternoon scene, a morning portrait, an interior, yet another sunset. You could try putting all the morning shots together, then the interiors, then the sunsets. Once you've done that, you may realize quite how many sunsets you shot, so perhaps you can trim down the numbers. Or there's a picture you really like, but it does not fit into the sequence anywhere: if it disrupts the collection, it may have to be left out.

Using the web

The Internet offers not only a means to communicate and share between millions of web users, but the capacity for data is now so enormous, that it is becoming a repository of all kinds of information, including digital images. As a result, what you can do with digital imaging on the web is growing rapidly.

Picture-sharing websites

At the time of writing there are nearly a hundred different picture-sharing websites around the world. Some are run by enthusiasts for special-interest groups – including photography itself – while others are complex sites administered by the big names in the photography industry such as Kodak, Fujifilm, and Canon. The majority of sites are free for the basic services, but they hope you will be tempted by the fee-attracting extra services and facilities.

The principle is that once you register, you are allocated a space to which only you have administrator access. This means that only you can add or remove pictures and other information. Once you have made your selection, you simply follow the website's instructions to size, tag information and, finally, to download your pictures to your own personal web space. On many sites, you can decide whether to allow anyone access to it, or only a select few to whom you have given a password. This means that even quite sensitive material can be published – although, remember that your material will be inspected by the website's masters to ensure it is legal and not objectionable (or actionable) in any way.

Other web services

A natural extension to displaying your photos on the web is to store them on the Internet: use the storage capacity of a computer centre to save your photos, instead of your own computer's capacity. This off-site storage is common in business, and is spreading quickly for private individuals.

One big advantage of off-site storage is that you can access it wherever you might be: you do not have to be logged on at home. In theory, then, while 12,000 miles from home you could save pictures taken on a previous holiday, accessing shots taken last year. Or, suppose you were far from home and shot some lovely, once-in-a-lifetime photos. You are terrified of losing them. You log on at the first Internet café and send those shots to your off-site storage. That is as secure a place for your files as anywhere on the planet.

In the main, any of the on-line printing services, or those hosting picture portfolios or sharing services, effectively provide you with off-site storage (http://www.ofoto.com/ http://www.shutterfly.com/ the iDisk service part of .Mac at http://www.mac.com/ http://www.fotki.com/) because you can limit the picture-sharing to yourself if you wish. Some sites have limits on what you can store, but the basic premise holds. The clearest model is in the .Mac service.

With some new services, such as Kodak Mobile, you do not even have to log on: you can send pictures from your mobile phone to the site.

Web printing

Another distinctly different way of using the Internet is to obtain prints of your images. You simply send your picture to the site and tell the service the size and kind of print you want and pay by credit card over a secure connection. You will receive a print in the post in a few days. Indeed, on many of the picture-sharing sites, you do not need to download an image because you will have already done so; when you need a print, just point the service to the relevant picture. On some sites, you can join forces with the service to sell your work: anyone who wants a print can order one, paying you a small fee in addition to the cost of printing.

You will find some picture-sharing services easy to use and responsive, while another may place its pictures on a deeply coloured background, which is a visual eyesore, or the site is unresponsive and slow to work. Also some are easy to navigate and use, while others take more figuring out. Some sites feature a lot of travel photography of a high standard, while others will major on party pictures and friends playing pranks. So you can also select a site by ensuring the kinds of material it shows is companion to yours.

Learning from websites

Another type of data that is available, and also in vast quantities, is information. You can learn a good deal of photography from the web. You can read tutorials on how to use digital cameras, how to manipulate images, how to design web pages. You can learn about reviewers' opinions on digital cameras and other accessories before you make your own purchases. And, if you are technically inclined, there are some sites that penetrate some way under the surface of photography. The quality of material is highly variable. Broadly speaking, it is better to learn from specialist photography sites than from a general one offering 'easy-to-understand' information; and from sites put out by reputable manufacturers such as Kodak, Canon, Adobe, and the like. If you find the information too technical, the likelihood is that it is written by someone who knows what they are talking about – it is better to persevere with one of these than reading a dozen introductory treatments.

Personal web pages

One of the inflationary forces that fuelled the madness of the dot com shares bubble was the high fees charged by those with the skill to create websites. Those days are over now that websites can be created by selecting a few options in software menus. Even quite powerful sites with commercial features can be created by anyone using freely available software that is no more demanding than image manipulation applications.

Personal space

Internet service providers – the companies through which you connect to the Internet – generally offer some personal space. It is an allocation on the hard-disks of the large computers which control the web traffic, such as calls to websites and emails. With personal space of 50MB or more, you will have more than enough capacity for many personal web pages (pwp) full of pictures.

Creating pwp

The toughest part of making your own website is getting the pictures in the first place. Thence, software such as Photoshop Elements, Extensis Portfolio or Fotoware Fotostation can step you right through the process, giving you a choice of web page design and the ability to customize some features such as the text used, and its style.

The flashier styles – with coloured backgrounds, textures and graphic devices – may be the most immediately appealing, but once you place your images on these designs, you may feel that they overwhelm or crowd your images. Ideally you would design your images to work with the backgrounds: they might have to be very striking, with colours that complement the website background. In short, you will find it easier to work with the plainer designs.

You will need to tell the software which pictures you wish to place on the website. The majority of applications will simply sweep through a folder, collecting all the pictures it finds and placing them on the web pages in the same order in which it found them. Therefore, a little preparation is useful.

CREATE WEB GALLERY
In Photoshop Elements, you start to create a web gallery or personal web page by choosing the command from the File menu.

STYLES
Choose a suitable style: samples are shown below.

STYLES DISPLAYED
The first choice you have to make is the style of the web page design. A small thumbnail shows what the style looks like. Here, they have been collected together; in the software they appear as you select each one.

Basic image preparation

You can prepare images to different standards, putting in more or less effort. Here we describe a basic routine (a more elaborate one is described on pp94–5) and consider some technical issues.

First, copy all the images you want on your website into a new folder called 'Photos for Web' or something similar. In this way, you will not harm your original images. Work out in which order you would like them to appear, bearing in mind some of the thoughts discussed on pp88–9.

Now, rename them all. Use a system that starts with a number with a leading zero such as 01webpic.jpg, 02webpic.jpg and so on. If you number without a leading zero, 10 may be read before 1.

WEB PAGE WITH THUMBNAILS
This page design allows a large number of thumbnail pictures to be held in a scrolling bar at the bottom, with a larger image showing above. There is a lot of room for notes and written details.

WEB PAGE WITH BACKGROUND
This page design offers an attractive basic background colour that is not quite neutral, but the texture tends to dominate over any but the most assertive image.

WEB PAGE WITH THUMBNAILS
This design offers an overview of a set of thumbnails, with a detailed view that is not much larger, with some room for text. It is easy to use and understand.

WEB PAGE WITH BACKGROUND
Using a warm and nearly neutral background colour without texture makes this design attractive without competing with your own pictures. The thumbnails at the bottom of the page make for easy navigation.

More image preparation

Preparing your images for the web involves principles similar to downsizing images before emailing them: the need to balance file size against quality. The smaller you make your image files, the more rapidly your page can be viewed in its entirety. And the less your website visitors have to wait, the more they will enjoy your site. However, if you compress the image too much the quality can deteriorate to the point where the picture cannot be enjoyed anyway (see pp86–7). However, there are some tricks that can help if you have many images to process.

Monitor standards

For all the work so far, we have assumed that the monitor on which you work is calibrated (see pp52–3): well adjusted in terms of its colour, brightness and contrasted. Also we assume that you are working in conditions conducive to assessing image quality. That means that the room is not too bright, with no direct sunlight while working; there is no lamp shining onto the screen; and the walls are not strongly coloured.

If you work on a Windows personal computer and with a monitor adjusted for Windows, then you can be confident that the majority of computer users will see images fairly similar to what you can see on your screen. However, Macintosh users will find your images rather darker than at their best. By the same token, if you are a Macintosh user and you adjust your image to look right on a screen calibrated to Apple Mac standards, then Windows PC users will find your images a little too bright. The best solution is to compromise a little: Apple Mac users should adjust their images until they are a little darker than they would like, whereas Windows users would adjust their images until they are a little brighter than ideal.

IMAGE ADJUSTED FOR MAC

IMAGE ADJUSTED FOR PC
These two images simulate the differences you might expect to see when comparing the same image on two different screens. Note that the PC image is not only darker, but the colours also appear richer. Not seen side-by-side, the differences may not be significant and not a serious cause for concern.

Cropping images

Whatever you select or decide to do for your web presence, you are sure to be resizing and cropping many images. Cropping may be necessary, because you will want to remove any image that is excess to requirement – a splendid way to cut down file sizes. Resizing or down-sampling is the process of making the image smaller so that it is at the size needed for viewing. For viewing on the monitor, you need only decide how many pixels wide your picture should be. However, it really improves the overall effect if your images are all exactly the same size and proportions.

For this, the best tool is the Crop tool. You can set it to, say, 240 x 180 pixels and draw the Crop tool over every image that you open. The resolution is usually set at 72ppi (pixels per inch), although, in fact, it does not matter what you set it at. Using the Crop tool is much easier than using the Image Size menu. Once you have cropped the image, you can save it as a JPEG file in your folder for web images.

CROP OPTIONS
Enter the size you require into the Crop tool options and crop every image to exactly the same size with minimal effort, each one taking only a second to do.

IMAGES FOR WEB
This shot of pictures in an image management software shows that every image is exactly the same size. They were named descriptively, since they were to be used in a manually built website.

TA WEB PAGE
One of the pages from my website, www.tomang.com, shows its simple design – not unlike those created automatically by software. But it has many more features and a more complicated structure of sub-pages and sub-sub-pages than is possible to create automatically.

JPEG

Scientists and technicians of the Joint Photographic Experts Group (JPEG) worked out a format for image files that could be adopted internationally. It uses 'old-fashioned' mathematics to make files smaller by disposing of variable amounts of visually unimportant information and by re-organizing information so that it takes up less space. The disposed data is irretrievably lost, hence JPEG is called a lossy compression. Disposing of a small amount of data makes no visible difference to the image, but can substantially reduce file sizes. Most important is that it is the one format that can be opened by all Internet browsers, image manipulation, picture management, printer and presentation software.

ALTERING
digital images

Checking the image

Once upon a time, photographers were promised: 'You press the button. We do the rest.' One consequence of the digital revolution is that the phrase should now read: 'You press the button. You do the rest.'

Image health

You now hold the responsibility for the image in your hands. Bad news for some; but if you are reading this book, it is good news because it means that you can make the image far better – closer to what you want – than anyone else ever could. After all, no-one can read your mind.

Before diving into the zillion things that you can do to improve (and mess up) an image, it is prudent to check that it is actually worth working on. That is because images lacking in data are difficult, if not impossible, to correct fully, and very resistant to improvement.

So you want to be sure you will not be wasting your time. The easiest way to do so is to check the Levels display that shows the different proportions of light and dark pixels. In Photoshop Elements, this is under the menu Item Enhance > Adjust Brightness/Contrast > Levels. The illustrations below show the shapes typical of the display and what you should be looking for.

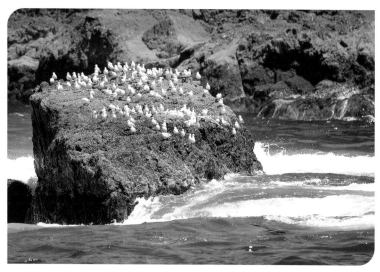

NORMAL LEVELS
With a normal exposure with a fair range of tones, you obtain a Levels display that looks like that shown above: everything is centred around the middle which means most of the pixels are around mid-tone in lightness. Ideally, the central pile spreads right out to the extreme left and right, showing that there are some extreme black and some extreme white pixels.

Resolution enough

Check that the resulting file size is suitable for your needs: 2MB is fine for ink-jet prints of up to 3x5", 5MB for 10x8", 6MB for A4, 12MB for A3. For emailing, images should not be larger than about 200KB before compression. The larger the print, or the more exacting your standards, the larger the file you need. For sending images in email, the file can hardly be too small. And when you crop, bear in mind that the process discards data in an irretrievable way.

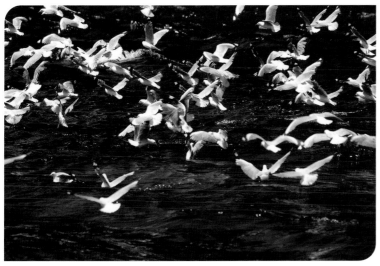

DARK LEVELS

With a dark image, the pixels are all dark and therefore tend to bunch to the left – indicating they are all darker than mid-tone apart from a very small number which cover the range all the way to white (the right-hand side of the display). Note that this is a correctly exposed image: it is meant to be rather dark.

BRIGHT LEVELS

In contrast to the shot against a dark blue sea, one in the opposite direction and showing lots of sky is much brighter, resulting in a Levels display in which the peaks are situated to the right of the display, indicating there are many pixels which are brighter than mid-tone. Again, this is a properly exposed image: the sky is meant to be bright.

POOR LEVELS

If the camera had made an error – it may have set for one lighting condition but the lighting changed just before the shot – or it made an error in processing the image – the resulting shot is deficient in data. The Levels display shows a broken comb-like pattern indicating many gaps. This image is impossible to correct fully.

The most powerful tool – the crop

Once you have established that your image is in good digital health, you can start working on it. We know that image files are very large compared to any other file you would work with (other than video, which are even bigger). At any rate, you will want to work with a file that is as lean and light as possible: this speeds up operations and you wait around for less time.

The crop

The crop tool trims off the excess outer portions of your image to save on file size. This is often useful when you receive scans from a bureau or laboratory: scans are often made with a little extra black border to avoid cutting into your image. You need to trim off the excess black portion not only to save space but also because it can distort some automatic adjustments.

To crop, you simply pick the Crop tool, click and drag over the image. When you release the image, the margins will be shown: you can then adjust individual sides until you are satisfied, then hit the OK or Return key to accept the crop. You will see that even a small crop can make a big difference to the file size. You should check this to ensure that the file size is sufficient for your purposes (see p99).

The intelligent crop

Cropping is a powerful way to improve the graphic impact and visual coherence of a picture. The idea is to remove that which is not necessary, helping to lead the viewer's attention to the emotional or visual heart of the picture. Purists believe that you should have organized and composed the picture so that nothing extraneous finds itself within frame. Should we all be so skilled, fortunate or demanding! The rest of us will trim our images of excess as and when our imperfect photography calls for it. There is nothing to be ashamed of.

PALMS BEFORE CROP
Overhead a botanical garden in Singapore, we are attracted by the patterns of the palm trees. But the rectangular frame takes in more than we really want – the textures of the other plants are a distraction.

PALMS AFTER CROP
We crop out the central section, rotating the crop slightly to get as much of the palms as possible and as little of the other trees as possible. The result is a cleaner, more graphic image.

Corrective crops

A common error is not holding the camera horizontal when photographing a landscape, so that the horizon is slightly at an angle. It only becomes apparent when the image is printed or on a screen when you have keenly straight lines to measure against your picture. Cropping is the easiest way to cure the defect: you lose a bit, but by rotating the crop area a little, you can correct shots taken at a slightly wrong angle.

FENCE CROP SHOWN
This shows the technique for lining up a crop with an important line: draw a long crop near the line that needs to be horizontal, then rotate – usually by dragging on the corners of the crop – until the sides of the crop line up with the horizontal. Now extend the sides until they reach the edge of the image.

FENCE AFTER CROP
The straightened image is far more satisfactory than the original: although the error was small, it made for unsettled viewing to the detriment of the image. The crop does not alter the facts, but improves the experience.

Creative crops

The basic rectangle of a photograph is not set in stone: for some it presents a welcome discipline and challenge, for others it is an unnecessary restriction. If you take the latter view, you can crop the rectangle into a letter-box shape or into a tall column. And why not – if the imagery suits the shape? In consequence, the humble crop tool becomes an extremely powerful picture-creating facility, achieving more with less effort than any other tool – and several of them put together.

Wide

A wide and narrow format image is the easiest to work with and often goes down well with viewers. It simulates a panoramic view even though the field that is covered is normal (for details on true panoramas, see pp136–7). It is worth experimenting with this crop on any image: the results are often surprisingly rewarding: it's amazing how little you miss the top and bottom thirds of nearly any image.

BEFORE CROP
A relaxed holiday scene in North Island, New Zealand is framed by the awnings of a tent and the shadows it throws. But perhaps there is just too much tent compared to the scene we are really interested in seeing.

CROP DISPLAYED
We try various croppings of the scene, choosing the cropped areas to be shown under a shield of red to stand out well against the uncropped areas. A long letter-box shape seems most appropriate.

AFTER CROP
Once we have performed the radical crop, elements which seemed simply to be distractions, such as the fringe of the tent and the various poles and guy-ropes, now become key to the picture. And our eyes are drawn through the foreground to the sunny scenes in the distance.

Altering digital images

Tall

The tall and thin format picture is rather trickier to get to work. Perhaps because it is more of an unnatural visual experience than the wide, pseudo-panoramic view. This makes it all the more interesting to work with, since success here is likely to lead to unusual results that will captivate your viewers. When it comes to printing images out, remember that you may be able to get two or more tall images side-by-side.

VERTICAL BEFORE CROP
A rather straightforward street scene in Auckland, New Zealand has, nonetheless, some promising contrasts of colour and line. At the same time, we notice that the camera was not quite vertical when the shot was taken.

VERTICAL AFTER CROP
We perform a rather fierce crop to bring the picture to its essentials about harsh man-made lines contrasting with the softness of the natural sky, at the same time rotating the crop a little to counteract the verticals.

Live and dead space

When you wake to the power of the cropping tool, it is tempting to slash at every picture with it. Time to recall the precepts of classical painting. Space or emptiness is not the problem, visually, but what it is doing. Space around a portrait is usually live or active space: it helps shape the face, give it context and visual room to breathe. Space in the foreground of a landscape is often dead space: it does nothing for the picture: does not invite the eye there nor does it lead the eye anywhere else. Intelligent cropping is the effective removal of dead space while reducing live space as little as possible.

Exposure correction

Correct exposure, as we have seen, is a flexible and movable matter. Even within the context of your own photography, you may simply change your mind about how a picture should look. In traditional photography, you would return to the darkroom to make a lighter or darker print. In digital imaging, you do exactly the same, but this time the negative is the original digital file – from this 'digital negative' you can spin off as many variants as you wish.

Working on a duplicate

Just as you should guard an original negative with your life, so you should preserve the original digital file. It is a law of digital imaging that losses inflicted on a file will be transmitted for-ever, unless made worse: they cannot be recovered. So in all you do, you should work on a copy or duplicate of the original file. The best process is to open the original file, then immediately re-save it as another file, using another name and saving it to a different location – ideally another hard-disk drive. Besides, the re-naming is needed to change the cryptic 'IMG_12345.jpg' into something more memorable like 'white_sands01.jpg'.

FALCONING DARK

In this type of image it is fine to force the pixels to go dark: this is not a true silhouette (see p71) as the original image showed details within the shadow side. But by severely cutting down on bright pixels, darker details have turned to black, creating the effect of a silhouette.

Not using brightness/contrast

One piece of advice often found in books on digital imaging is to avoid using the Brightness/Contrast control. The reason given, if any, is that this control destroys image data which is irrecoverable. This suggests that the use of other controls, and the Levels control in particular, does not destroy image data. This is misleading. Any control can destroy image data – in some cases even if you immediately reverse the effect, a little bit of data is lost. The reason why the Levels control is preferable is because it does everything the Brightness/Contrast does – but a whole lot more besides, as a glance at the controls makes obvious.

Finessing exposure

Adjusting the exposure or brightness of an image means that you are telling the software to change the brightness of all pixels by a certain amount. This is done on a slider or control, and in all software, you can see the effect of changes on the image. When it looks as you want it, you accept the change by hitting the OK or Enter key. One useful trick is to toggle between the before and after images to compare them: hold down the Control (or Command for Mac) key and hit the Z key to switch from before to after, and back again.

The control, which is technically correct and at the same time easiest to use, is the Levels control. This will be familiar to you from the examples on pp98–9. Click on the central triangle under the histogram graph and drag with your mouse. The central triangle represents the mid-tones, so dragging it to the left makes more pixels lighter than mid-tone and the image becomes brighter. Conversely, dragging the triangle to the right makes the image darker over.

BUTTERFLY NORMAL LEVELS
The image as exposed by the camera is reasonably accurate, but somewhat lacking in character. Notice the central slider is in its default position midway between the left-hand (shadow) and the right-hand (highlight) positions.

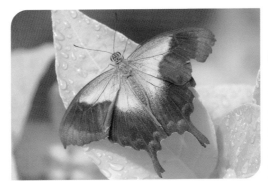

BUTTERFLY WITH EXTRA EXPOSURE
By moving the central slider to the left, we instruct the software to ensure that more pixels should be lighter than the mid-tone, as a result of which the image becomes lighter. This pallor may appear unattractive, but nevertheless correct if you print on a laser-printer, which tends to increase contrast.

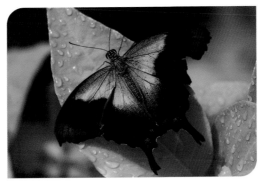

BUTTERFLY WITH LESS EXPOSURE
Locating the central slider to the right tells the software to make more pixels darker than mid-tone, which appears to favour the already dark pixels. This tends to increase the contrast and richness (saturation) of the image and may be all that is necessary to improve the colours of a print that appears too weak.

Exposure and contrast

Adjusting the overall brightness or exposure of an image is only the first step to mastering its tonality, or the way in which the gradation from dark to bright is managed. You will find it very satisfying when you give an image just the right and appropriate amount of tonal gradation. The contrast of an image brings two measures together. The rate at which shadows change to bright areas is one: it is analogous to the steepness of a slope joining low to high ground. The other is the difference between the brightest and the darkest areas: this is analogous to the distance between low and high ground, and is the dynamic range of a scene.

PLAN€ AND TR€€ ORIGINAL

PLAN€ AND TR€€ HIGH CONTRAST
This pair of images shows the dramatic, and useful, change wrought by hefty changes in contrast and brightness. Notice how the colours start pale but become deeper and richer.

Sensible limits

Contrast is intimately tied to the exposure level: broadly speaking, you have the most control over contrast when the exposure is right. You will have the most room for manoeuvre. However, that does not mean you can soften tones or jack up contrast as much as you like. Not only is the ceiling set by the image's own requirements, but also by the limitations imposed by the way you output or view the image.

But don't let these formal criteria spoil your fun: try extremes of contrast – both high and low – on different images to learn about the deep effect of contrast on the way you read and experience an image.

Rate of change

Now, when we bring all these factors together, we have lots we can play with. You can make the rate of change – the slope – from dark to light very steep, so there is very little between black and white. This gives strong graphic effects, great with subjects with clear outlines or shapes. A shallower slope pulls out all the mid-tones and is the ideal for landscapes and faces, where much of the beauty is in a smooth, unbroken scale of lightness.

A small difference between light and dark is typical of a softly lit day through heavy clouds or the light from an open-plan office: shadows are indistinct, highlights not brilliant: perfect for nude photography, pastel flowers and fashion. The opposite gives you sharply defined shadows, richly deep dark areas and brilliant highlights with strong colours: suitable for hard commercial photography and graphically designed images.

LOW CONTRAST
On a cloudy day in Morocco, the shadows are almost nonexistent, all contours and colours are soft. Everything in the picture then hinges on the composition, the timing and sheer good luck.

SOFT NUDE
The original image shows normal contrast, but this version – with reduced highlights, shadows and lowered contrast – helps convey the softness and sensuous shapes of the body. There is only just enough shadow/light differentiation to define the form.

The power of curves

Curves are a representation of contrast changes rather like a cross-section through a hillside – a steep slope represents high contrast, and the longer the slope for a given steepness, the greater the difference between the light and the dark. The great thing is that in more advanced image manipulation software, you can directly change the shape of the curve.

BUTTERFLY WITH EXTREME CURVES SETTINGS
This gaudy image of the butterfly, seen in previous pages, shows what a few seconds' work with the Curves control can achieve: the effects are fantastical and of limited use, but good fun to play with, provided your software offers a Curves control.

Colour control

In the ordinary course of events, you need not worry about colour control in digital imaging. The electronic systems in modern digital cameras blend high technology with a good understanding of human vision so that your images look attractive and acceptable. There is no mention of accuracy here: what matters is that you like the image and want to show it or use it. Indeed, there are times when an accurate rendering will be unacceptable. The classic example is that of twilight colours: an image accurate to our visual memory will come out too dark, weakly coloured and low in contrast.

Colour temperature

How the colour we see becomes a colour that is captured by the camera, which is in turn reproduced as a colour in a print or on a monitor, depends on a beautifully complicated system of lighting, individual vision and material properties. One of the key elements is the whiteness of the light that illuminates the scene.

Compare the whiteness of the light streaming from an equatorial sun through a cloudless sky to the light of the same sun at sunset forcing its way through dusty, humid air. The midday light is very white compared to the cuddling orangey hues of the evening sun. Same light source, utterly different effect. Their difference is measured by colour temperature, in units called the Kelvin. A white or bluish source is said to be a high-colour temperature source (e.g. 9300K), while a yellow or red source is a low-colour temperature source (e.g. 5000K).

The difference in colour temperature of illumination explains why the same scene or subject can look different in changing light, and why there is a problem with colour accuracy. We have to decide what, exactly, are a subject's true colours.

WARM DOORS
In this almost monochromatic image, everything depends on the warm hue for the furniture lit by morning light. But because there is no reference to any 'memory' colours for accuracy, you can choose the colour you like best. The key is that the highlights should be neutral.

WARM DOORS PINK HIGHLIGHT
If the highlight is set to a light pink, as in this image, the overall effect is still entirely acceptable, but we start to suspect that perhaps the colour is not accurate. How can it be, if the whitest light (far left of image) is not white?

Correcting poor colour balance

Digital cameras measure the colour of the highlights – they look at the brightest areas – and work out the compensation needed if the illumination is not a true white. If it is a little bluish, the circuitry adds a bit of red to balance. If the illuminating light is a little yellowish or reddish, the circuitry adds blue-green or green to compensate. Poor colour balance results from errors in these compensations. These errors can be caused by the illuminating light being so strongly coloured that it falls outside the ability of the circuitry to correct.

The neutral white

Corrections can be done in the image manipulation software. The easiest way is to press any auto-correction button that you can see and hope that the image will improve. The chances are indeed that your image will improve. The key to this process if you want to be in control is to locate any area in your image that should be neutral in colour: white that should be white, grey that should be grey or black that should be pure black. After all, that is what the software does, although without the same refinement or ability to 'cheat' (choose a patch according to which to correct). Then you need to tell the software 'This should be neutral: make it neutral and apply the same correction to all the other colours' – technically speaking, you map, or relocate, all other pixels around the patch that you sample (point to). This is usually done with the Dropper tool, available in almost every application. Simply choose the appropriate tool (usually you get a mid-tone if there is only one, or a highlight and a shadow) and click on your chosen patch.

COLD SHADOW PORTRAIT
Taken on a partially clouded day, the colours too bluish overall to be correct, with the result that the skin tones are none too attractive. The blue tone has counteracted the warm colours of the skin tone to make them neutral.

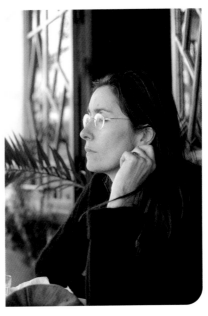

WARMED SHADOW PORTRAIT
We call up Levels, then select the tool by clicking in its box. Then we click in a highlight which we want to be neutral. If you miss or do not like the result, just click once more. In this instance, it took just one click for the portrait to be corrected.

COLD SHADOW LEVELS
The Levels control from Adobe Photoshop Elements is a model for other controls of levels: the dropper that is shown clear represents the one used to point to the part of the image which the software should turn into neutral highlights.

Improving colour

Colour is not, as we have noted before, merely about accuracy. There seems to be a widespread instinct through-out nature to prefer brilliant, rich colours to pale ones – certainly when it comes to choosing mates, defining tribal allegiances and scaring enemies. These atavistic proclivities are preserved in digital imaging: there is an almost universal preference for the highly saturated colour (one that is very rich in colour) instead of the low saturation colour, one that is pale and weak. (Even the words we use also conspire to sustain the prejudice.)

Saturation

Saturation measures the purity of a colour, which translates to the intensity of the visual experience of the colour. For a number of technical reasons, digital cameras tend to deliver images that are not as saturated as they could be, or as we might prefer them.

As a result, one of the most frequent image manipulations carried out to an image is to ramp up the saturation. This produces colours that are visually more striking and appealing. However, you may find that increasing the saturation of a portrait against a landscape may do lots of good for the topographic view, but the results in the person's face are not at all pleasant. Their skin colour could become blotchy and peaky.

There are two issues here. One is that too much saturation is as undesirable – if not more so – than too little. Too much saturation can cause bright colours to blend into one another, so losing any discrimination in the hues. The other is that we might like to be selective about what we saturate. Indeed, the way digital cameras record colours means that they tend to favour certain colours over others. Selective saturation can be handled from the Hue/Saturation control available in most image manipulation applications.

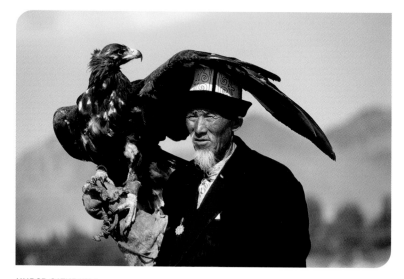

UNDER-SATURATED
The original image is overall a little pale in colour: the saturation in all colours is too low.

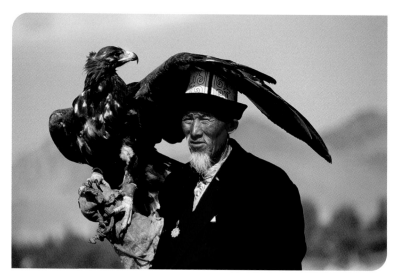

OVER-SATURATED
If we increase saturation all round, the background improves very nicely, but the face then becomes far too strongly coloured.

EXTRA SATURATION

The Hue/Saturation control can change colour saturation overall, as shown here, or selective to limited bands of colour (see below).

SELECTIVE SATURATION

You can choose bands of colour by clicking on the drop-down menu for the colours you wish, then refine the choice simply by clicking with the pointer in a suitable area. Then click-drag the slider until you obtain the effect you seek.

Another reason we need to be careful about enthusiastically increasing the saturation of colours in the image is because the vivid colours you see on the monitor screen may not come out in print. These colours are said to be out-of-gamut for the print process you use. So you need to beware that the brilliant purples, deep blues and greens visible on your monitor may not appear in print. (See Chapter 9.)

SELECTIVE SATURATION

Using the ability of the Hue/Saturation control to limit its effect to bands of colour, we choose the blues and greens to boost. This avoids the reds of the skin tones. The image is much improved over the original without paying the price of unnatural skin tones.

Trouble-shooting: image errors

You may notice features in your image (sometimes only when viewing it on a screen) that are not a part of the image: these are image artefacts – caused by the system or by errors in the image. Some can be corrected; one or two may not need correction; while others are very difficult indeed for even the experts to deal with.

Stripes or patterns appear that were not in the original scene. On a computer monitor, you may notice that sometimes the stripes appear but disappear if you change the size of the image. Stripes appear on pictures of railings, roof tiles or other fine pattern.

SCREEN MOIRÉ
The striped pattern (shown by the pointer) appears only at certain magnifications of the image. The exact figure will vary with the screen size and even the make. But it does not appear on the image when printed or when copied.

The effect is called *moiré*. It is caused by a third pattern emerging when two, slightly differing, patterns are superimposed. The first pattern is in the subject (e.g. roof tiles), while the second pattern comes from the pattern built into your camera's sensor. With these two superimposed, a third pattern will emerge.

It is called scene moiré when a regular pattern in the scene interacts with the camera's sensor pattern. It is called screen moiré when a pattern in the image interacts with the (monitor) screen's pattern of phosphors or LCD cells. So, a pattern in the scene may fail to moire when captured, but cause moiré on the screen.

MOIRÉ
The coloured patterns are an artefact caused by the interaction of the roof tile patterns with the patterns of the camera sensor. These are all but impossible to eliminate, but fortunately occur only rarely. Besides, they can only be seen at high enlargements.

You have stumbled across one of digital photography's big technical problems – one with which the experts have a lot of trouble. It is impossible to avoid entirely. Fortunately, while the moiré you see on screen is disturbing, it has no effect whatsoever on the image. Scene moiré is very rare, its impact on the image is slight and can be reduced with specialist software.

MOIRÉ ORIGINAL
The original image shows that the moiré is invisible in small images.

Bright areas in images come out completely white, or nearly white, without details or colour.

Explanation

The range of brightness is too great for the sensor or film. And if the film may have coped, the result may be more than the scanner could work with. As a result, either anything in shadow will be totally dark in order for the highlights to register detail, or there is detail in the shadow but the highlights are 'burnt out'.

BURNT-OUT HIGHLIGHTS
In this image of Angkor Wat, taken during a tropical midday, the pounding sun on the smooth rock and the deep shadows in the temple make it very difficult for any medium to record faithfully. But the strong, simple composition saves the day.

Strategy

Avoid shooting in the brightest, most contrasty conditions if possible. If you still wish to photograph, at least try to keep the highlight areas as small as possible. Also try to create a clear, strong composition – one which does not rely on subtleties of tone or colour.

Correction plug-ins

You may find that all the various controls needed to improve an image confuse you. Indeed it is easy to chase your own tail as one correction may alter an earlier change. Plug-in software such as Pictographics iCorrect EditLab provide quite powerful, but simplified, colour corrections. Extensis Intellihance can apply a powerful and wide range of corrections to an image – not just colour, but also sharpness, tone and contrast as well as controls to reduce certain image artefacts (unwanted image details). For those with many images to process, it is a favoured tool.

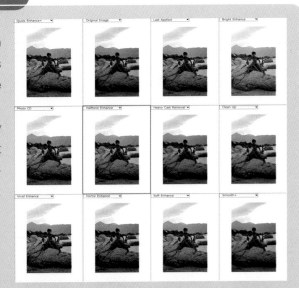

CORRECTION PLUG-INS
One of the ways that Extensis Intellihance works is by offering you a range of different sets of corrections and manipulations: just view from the 'catalogue' of effects to choose the one you most like. Each effect can be fine-tuned.

Removing colour

The electronic 'eye' is essentially colour-blind. It sees only in shades of light and dark. Camera manufacturers and scientists have had to go to extraordinary lengths to force the system to record colours. So it may seem perverse to ask for the colours to be removed, in order to produce black-and-white images.

Working in pastels

We can remove colour in stages, to learn about the potential for the image at each stage. The first measure is to reduce the strength of the colours: from the intense, we create the pastel, from the saturated, we create the pallid. The resulting images are then softer, milder and more fluid in visual impact compared to their richly coloured siblings. This can suit portraits, homely interior views as well as pastoral views.

For pastel images to work at their best, shadows are generally kept quite light and do not occupy much of the visual surface. Contrast is kept low as well, so there are few, if any, black tones and few purely white ones.

ITALIAN ORIGINAL
A charming corner of an Italian hotel, full of light and colour. But I felt the brilliant lights and high contrast with intense colours was a little too literal, too photographic an image.

ITALIAN LIGHTENED
In preparation for desaturating the colours, which I know tends to make coloured mid-tones look too dark and grey, I lightened the image overall and reduced the blacks to create a high-key intermediate (see p71 for more on high-key).

ITALIAN DESATURATED
This image was obtained by applying a broad and heavy desaturation, together with a reduction of the shadows. It is a matter of taste whether you prefer this version, with its pale colours and pallid impression like that of a faded print, to the lighter, brighter and more colourful predecessor.

Working in monochrome

The next step in colour reduction moves into a different dimension: it declines all but one band of colour. This is true monochrome – literally 'one colour'. Many of the most successful landscapes gain their power from parsimonious use of colour, which helps show up the extent and morphology of the landscape. The lack of colour removes unnecessary distractions.

The beauty of this way of working is that any choice of monochromatic colour can work. While warm colours such as reds, earths and oranges are most popular, you can work equally well with palettes consisting solely of greens, blues or even purples.

MARRAKECH LATE AFTERNOON
Ordinarily filled to bursting with a medley of colours, Marrakech does not suffer in this picture from lack of colour. Indeed, the restraint in the range of hues helps bring the visual attention round to the light and composition.

Why black-and-white?

The final step is to remove all colour and return to the simplicity and directness of the purely tonal image – unsullied, at least in some eyes, by colour. Some digital cameras offer a black-and-white mode. One side-benefit is that you should be able to save around three times more images onto a given size of memory. Photographically, the benefit of black-and-white is that it generally helps make photography much easier, with less to worry about. On the other hand, you need to remember that some colours which appear brightly contrasted – like reds and greens – may appear the same grey in black-and-white.

MARRAKECH STREET
The same street as opposite, but looking the other way, was indeed full of colours on the walls, lamp-posts and shop fittings. In black-and-white, the image cuts to the chase: the complex of lines, intersections and shapes leading to the face falling from the bottom of the image can be seen more clearly without the distraction of colour.

Using distortion to correct

Distortion changes the shape of an object. In digital imaging, distortion is an inevitable part of recording a three-dimensional object onto a flat surface. Your images may also suffer from another kind of distortion – that caused by aberrations or deficiencies in the way the lens projects the image. In practice, we turn a blind eye to all but the most obvious types of distortions. Fortunately these obvious ones are easy to correct with image manipulation applications.

Leaning towers

The railway tracks which converge to a point somewhere in the distance is a familiar sight: we know that, in reality, the distance between the tracks is always the same, so the appearance of tracks getting closer together is an illusion. The buildings which appear to lean backwards in your photographs is exactly the same phenomenon: the progressive change of magnification as objects are further away. This gives you the clue to correcting the effect, called projection distortion (because it is due to the way the image of the subject is projected onto the sensor or film). All you have to do is to enlarge the upper part of the image; in effect, you compensate by introducing a distortion of your own.

ORIGINAL BEFORE DISTORT
The leaning-back effect is not great, but it is present sufficiently to unsettle the image. And why leave it if a simple adjustment can correct it?

DISTORT TO BE APPLIED
In Photoshop Elements, you will be asked whether you wish to turn the image into a layer before you can apply a distortion. Agree to it, and you can then click and drag on the corners of the marquee (lines around the image). As you drag, you will see the image is distorted according to how far you drag.

DISTORT APPLIED
When you are happy with the distortion, you hit the Return key and the distortion is applied. Here, we see that the columns in the cathedral of Pisa, Italy are lined up with the sides of the image, giving a neatness and professional look to the image.

Deliberate distortion

As with every other tool at your disposal, distortion can be used not only to correct problems, but it can be used to refine a vision to bring an image closer to what you had in mind. Any tool can be used to repair, and can be used to create.

ORIGINAL STREET
Attracted by the street furniture and road markings, I had to angle the picture to avoid some debris in the street. But I was content to do so, knowing that I could make any adjustments later.

DISTORTED STREET
A big enlargement at the bottom of the picture, with some adjustments at the top to keep the tree centred and a change of shape of the image brings it closer to the interplay of lines and shapes which I had in mind.

Removing dust and clutter

In the early days of digital imaging, the tool with the biggest Wow! factor was the cloning tool (also rubber-stamp or clone stamp tool). This takes (or samples) from one part of the image (even from another image) and copies it onto another.

At first it was amusing to move someone's eye with only a few mouse-strokes. While such frippery quickly wore thin, the more prosaic ability to eliminate a speck of dust has not. The clone stamp tool is the Hoover of the digital imaging world.

Dust-free zones

Dust can reach film-based image at any time in its life, and usually does. Scanning is a superb way to pick up dust, but more and more scanners can remove the dust automatically (they mask off the dust, and do not physically clean your original). Nonetheless, you will still have to do some dust removal (retouching) by hand and remove scratches on film. Choose clone stamp, click on a clean area (this tells the software to sample from that area), click on the dust (or scratch) you wish to remove and drag the mouse over the spot: the original sample is put onto the dust, covering it up. The best technique is to use a brush that is close to the size of the dust being removed.

BOYS ON ROCK LOW RESOLUTION
It is important to realize that defects clearly visible on the monitor screen at high magnifications will simply disappear at normal, small print sizes. The scratch in the negative by the boy's head is very obvious on screen but invisible in a standard-size print.

BOYS ON ROCK SCRATCH
This scratch is easy to remove because the texture of the grain in the film helps disguise any errors you may make. Just take your time, and remember that if you do make a mistake, you can undo, retrace your steps and try again.

Deleting clutter

While there is no controversy over cleaning dust off an image, there is plenty over the rights and wrongs of removing clutter such as telephone wires and lamp-posts. In your own photography, however, the debate need not bother you. If it was impossible to get a shot of a sunset and avoid the power lines overhead, then so be it: remove them when you get home. The trick is to work at high magnification, slowly and methodically. If your mouse does not allow fine movements, but jerks around uncontrollably, then you need to replace it with a better-quality specimen, preferably with optical tracking – with a red light instead of a rubber ball at the base.

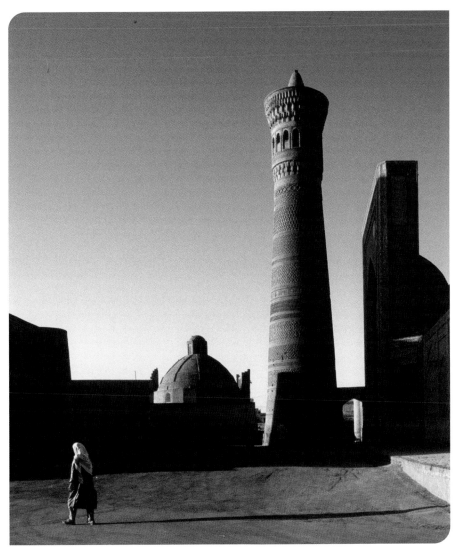

BUKHARA TOWER
This exquisite scene in Bukhara, Uzbekistan included some clearly defined wires strung right across its width. There can be no serious objection to removing these.

BUKHARA CLONE – POOR
Note that the gradation of blue in the sky is very subtle and fine: if you select as your source a blue that is not quite right, then you obtain this result: replacement sky that does not match.

BUKHARA TOWER CLONE – OK
It is possible to make corrections so that they are invisible even to the expert eye. You need to work slowly, and use many separate strokes. If working on a film-based original, try to imitate the irregularities of the grain.

Sharpening up the image

One of the cornerstones of an image is its sharpness – the quality with which details are defined. An unsharp image clouds the details, appears unfocused, a little blurred – as if it could be better. While a sharp image is almost always preferable, for the first time in the history of photography, it is possible to have an image that is too sharp.

Sharpening filters

It is important to distinguish between the presentation of detail – the sharpness – and how much detail there is in the first place – the resolution. An image that is poor in detail can be made as sharp as you like, but it will still appear low in quality. Sharpening filters work on the basis of increasing contrast at edges and boundaries, which improves their visibility.

USM 111 1 1
With a standard setting, we obtain a result that is applicable to a wide range of images and usable for a wide range of purposes. For the highest quality work, try reducing the strength setting to around 55%.

Not magic

You may be wondering if you can rescue all those pictures spoilt when you, or the camera, failed to focus properly. Sadly, the answer is no, you cannot use image sharpening to rescue badly out-of-focus images. The software needs some detail to work with, and what makes an image out-of-focus is precisely that there is no detail present.

USM 60 100 1
With a moderate strength, but very large radius, the overall contrast of the image is altered. This is shown exaggerated here, but in fact offers you an advanced technique for tonal control – one which many 'experts' do not know of.

How to sharpen

First examine the image at 100% or actual pixels: nominally, each pixel of your image is represented by a pixel on the monitor screen. You apply the filter and watch the improvements. In general, for printing out you should sharpen the image to the point it starts to look too sharp – with haloes around some edges – then reduce sharpening a little.

If you have unsharp mask in your application, a good starting point is to set around 111% for Amount of sharpening (strength), a Radius of 1 and Threshold of 11. Broadly speaking, you can use a larger strength if you set a smaller radius. You can use a larger radius if you have only broad shapes or lines, with few fine details. And you increase levels if the image is very noisy (full of small specks that you do not want made more visible).

USM 500 1 11
Since the important features of this image are the very fine details, we can set a very high strength for the sharpening –500 here – provided we do not set a large radius. The sharpening here is useful for printing onto matt paper.

HAWK USM 60 100 1

The high contrast of this image – due to setting a radius of 100 – with the resulting enrichment of tones, turns it from photograph towards illustration – and none the worse for that.

HAWK USM 500 1 11

Compared with the original, which was already sharp, this image shows a remarkable improvement in presentation of details obtained by applying unsharp masking: it is really better than the best lens could deliver.

Softening the image

Given our preoccupation with obtaining razor-sharp images, it is not obvious why anyone would want to soften or blur a photograph. The creative blur is in fact an art in itself, with half-a-dozen different ways to achieve subtly varying effects.

And we need them because sometimes cameras can reveal too much: too many spots or blemishes on the face of a portrait sitter; too many details where a wash of atmosphere would be more appropriate.

Selective blur

There are some uses for a uniform application of blur over an image. One instance would be an image that had been over-sharpened by a digital camera or photographer. Applying an overall blur will soften the harsh edges. In portraiture, you may want to flatter a face by using softening to hide skin blemishes. However, blur needs to be applied selectively. You can limit the application of an effect by selecting an area with the Lasso tool: 'round up' the pixels by drawing around the area you want to work on. Alternatively, select the area you do not want affected, and then select the inverse of the selection.

Depth of field

One application for selective blur is to improve the apparent depth of field of an image. A problem with the majority of digital cameras is that depth of field is often quite considerable – too much within the field of view appears sharp. This is a disadvantage where you want to separate different parts of your image by having the important areas sharp, the lesser areas left unsharp.

LASSO TOOL

LASSO OPTIONS
The Lasso tool 'fences in' the pixels which you wish to select: the selected pixels are the only ones in the image that will be affected by any changes you introduce. The 'feather' option shown has the effect of softening the selection, allowing an area of transition from selected to non-selected.

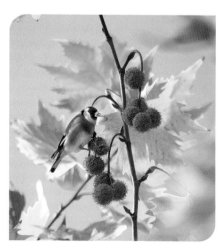

GOLDFINCH ORIGINAL

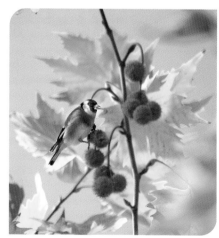

GOLDFINCH BLURRED
This snap of a bird is not only focused on the bird, but also on parts of the tree next to it. To bring out the bird it helps if its surroundings are out of focus, so that only the bird is sharp. To do this, I selected the sharply defined parts of the tree with the Lasso tool, then applied a blur to the area, re-applying the blur to increase the effect.

OLD WOMAN ORIGINAL

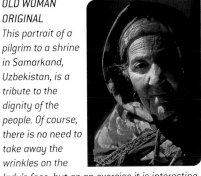

This portrait of a pilgrim to a shrine in Samarkand, Uzbekistan, is a tribute to the dignity of the people. Of course, there is no need to take away the wrinkles on the lady's face, but as an exercise it is interesting to see how much can be done.

How to glamorize

Making something look as you want it, not as it is, is unabashed image manipulation. With cloning (see pp118–9) you can remove skin blemishes and reduce wrinkles. Instead of aiming at neutral colours (see pp108–9) you can warm up the skin tones. You can change the shape of your subjects through distortion (see pp116–7). And, of course, blurring effects of various kinds can improve skin texture and reduce distraction from clothing. The examples here show blurring used selectively to reduce heavy wrinkles without blurring the entire face. And a simple transformation to make a hand portrait more glamorous.

OLD WOMAN DONE

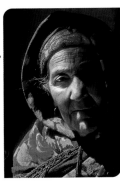

By removing the major wrinkles, the image is altogether softer, so that even the fierce shaft of sunlight appears less harsh.

OLD WOMAN SELECTED

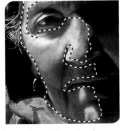

The trick is to select areas around the key outlines which must remain sharply in-focus, such as the eyes, nose and lips, as shown here: the selection carefully avoids boundaries which define the main facial features.

OLD WOMAN GAUSSIAN BLUR SCREEN

Gaussian Blur is a filter which gives you controllable amounts of blur: just drag the slider until you have just enough blur, and not more. Remember that printing out will tend to soften images further.

ORIGINAL

This study of hands, in black-and-white film, suggests elegance. However, it is tempting to take the suggestion further by elongating the hands to emphasize the elegance.

ENLARGED CANVAS

In preparation for the stretch, you change the size of the canvas (the space in which the image sits), which is normally the same as the image size, by making it 'deeper'.

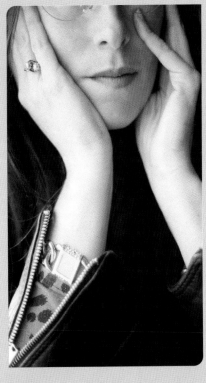

STRETCHED

Select the whole image, and choose the Transform function from the Image Adjust menu. Stretch the image until it looks right. However, because the tool stretches the entire image, it has stretched the face too much.

ADJUST

Select the face, call up the Transform function, and shrink it back a little: by separating the two operations you can apply different degrees of stretch to each portion selected. A little cleaning up, using the clone stamp tool, may be needed at the junctions between the two portions.

Image filters

By the same token that we can pick off individual pixels and change their colour or tone, we can group them and make changes to groups of pixels. This involves what computer scientists call object-oriented programming: we work with groups of small items as if they constituted a single object.

In digital imaging, filters take an image and churns it into groups of pixels. This makes it possible to apply textures and a variety of 'natural' effects such as shading, random distribution and random variation in qualities such as size, colour and shape.

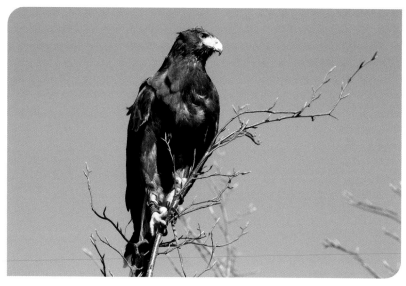

HAWK
The original shows the simplicity of outline and form which is best suited to working with filter effects.

HAWK ARTISTIC MENU
The menu choices under the Filters heading of the bigger and better image manipulation software offer truly numerous options, which can be greatly expanded by adding plug-in effects.

Filter	
Fresco	⌘F
Artistic	▶
Blur	▶
Brush Strokes	▶
Distort	▶
Noise	▶
Pixelate	▶
Render	▶
Sharpen	▶
Sketch	▶
Stylize	▶
Texture	▶
Video	▶
Other	▶
Extensis™	▶

Colored Pencil...
Cutout...
Dry Brush...
Film Grain...
Fresco...
Neon Glow...
Paint Daubs...
Palette Knife...
Plastic Wrap...
Poster Edges...
Rough Pastels...
Smudge Stick...
Sponge...
Underpainting...
Watercolor...

Art effects

The limits are set only by the imagination and technical abilities of the programmers. As a result, some of the effects will seem rather weird or spectacularly pointless. Enthusiasts may run competitions to see who can come up with a practical use for certain effects. Nonetheless, they are like the tool that lies forgotten in the bottom of a garage drawer only to save the day when nothing else will fit.

Even quite basic image manipulation software will offer 20 or more effects. Some demonstrate effects in a gallery show for you to choose from. The most useful to start with are the filters that imitate artistic effects, or the use of art materials such as paint and pastels. Or those which imitate an approach to sketching, such as tracing outlines.

There is no substitute for trying them all out to learn what they do. That task alone will keep you out of mischief for many hours. Some effects are illustrated on these pages; others are quite subtle and reproduce poorly, but all are best when regarded as the first or intermediate steps towards an artistic effect that you desire.

HAWK CONTÉ

The clean blue background provides a clear grey for the outline of the bird. Erase the branches you do not need and you have a lively graphic image.

HAWK PAINT DAUB

There are many variations on the Paint Daub, some more convincing than others. Those more capable than the filter provided in Photoshop Elements, allow you to work with changes of colour for greater effectiveness.

HAWK FIND EDGES

Similar to the Conté effect, Find Edges is a favourite for image manipulation because it gives something usable from almost any image. However, it is distinctive, so it is descending to the status of a cliché.

HAWK POSTER EDGES

This filter simplifies the colours at edges (posterizes edge details). It is useful when you want to print a small file to a large size and disguise the pixel structure as the edges help retain image shapes.

HAWK FRESCO

The Fresco effect (nothing like the transparency of the real thing by the way) is hard to predict, but all the more fun for it. Often it can be a one-stop solution for creating a clear, graphic shape.

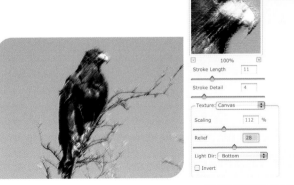

HAWK ROUGH PASTELS

It is down to personal preferences, but some people find this filter one of the more convincing. Unfortunately, over even areas, the repeated underlying pattern of strokes becomes evident: it can be disguised by reapplying the Rough Pastels filter with different settings.

Learning about filters

In order to learn about filters and to gain experience in using them, use fairly small files – not larger than 1MB. Do not use very small files, since the majority of effects vary considerably between small image files and larger ones. Try applying one filter after another; the results can be quite surprising – and it hugely increases the number of permutations you can exploit. Many filters can be applied at different strengths. Try applying the same filter several times at lower strengths, instead of once at a high strength. The effect can vary significantly.

Art filters

Another range of filters produce quite radical changes to the image. Some make no attempt to imitate art materials and, for others, their name is merely a gesture towards some superficial similarity in appearance. All have their uses, however, and you will enjoy learning how some kinds of images work well with certain filters while others are visual disaster areas.

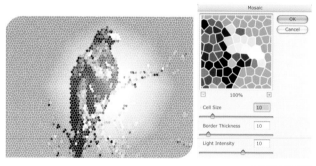

HAWK MOSAIC
The Mosaic filter breaks the image up into irregularly shaped 'mosaic' tiles (complete with grout) based on the image pixels. In some software, the filter adds a central glow. Good for subjects with lots of strong colours.

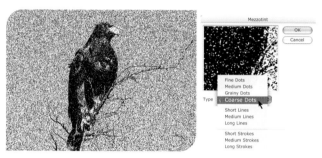

HAWK MEZZOTINT
One of the best ways to create image noise – random scatterings of 'grains' of light and dark pixels – is the Mezzotint filter. It goes about its business with less inhibition than the proper noise filters.

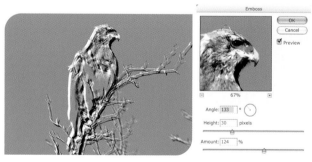

HAWK EMBOSS
The Emboss filter has similarities with some of the art effect filters, but it sets out to create a three-dimensional look which can be surprisingly effective and attractive in small prints.

HAWK POINTILLIZE
A variant of the Mosaic filter, the Pointillize filter breaks the image up into dots of similar colour. It is one filter that can be effective with subjects lacking clear outlines, provided they are colourful: flowers and coloured patterns, for instance.

Distortions

Distorting filters work on the entire image at once in order to shift the positions of pixels – which is a technical way of saying the image's shape is changed. These are top of the list of filters for which it is hard to find any obvious use. Those experienced in digital imaging find them most valuable when working with reflections, since these are often distorted (in rippling water or on a curved surface, for instance). Some of these filters are also handy when you want to create metallic surfaces.

TWIRL

Many of the distortion filters are most effective when used on small portions of an image at a time. This example shows the Twirl filter applied to two circular areas of the hawk image. An area has to be selected before invoking the filter effect.

GLASS

One way to understand distortions is to imagine you are viewing the image through irregular glass: in this instance, glass blocks. This filter, applied to a selection, is good for creating metallic finishes. The more experienced can define a texture to be used as a map for the distortion effect – last option on the drop-down menu of the screen-shot.

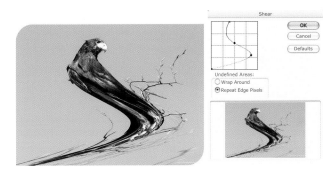

SHEAR

The Shear filter is actually quite a complicated distortion, one offering a good range of controls. It is invaluable for advanced work where, for example, you want to show distortions seen in a wine-glass

PINCH

Distortions can also create cruelly amusing results. It is easy to see this firing the imagination of a cartoonist, and being an inspiration for a card featuring a friend or relative (one with a sense of humour).

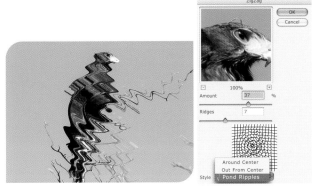

ZIGZAG

A reflection in the irregular surface of water is simulated by the Zigzag filter: here, it is set up to imitate ripples from a stone being thrown in. Not surprisingly, it is very useful for giving a real-life look when creating false reflections.

Layer opacities and interactions

Filter effects are impressive enough, but wait until you get a handle on layer interactions! These offer many ways to blend two or more images. Imagine that you have two transparencies or overhead projection slides: you can place one on top of the other – and there you have the principle. Suppose that where a part of one layer is dark, the other layer can be made lighter and the opposite (complementary) colour, or that you could blend the top layer so that it was only partially visible against the more visible lower layer. In digital imaging, we can do all that, and much more.

Opacity

First we consider how much of the lower layer can be seen through the upper: this is measured by opacity (the opposite of transparency). If the top layer is 100% opaque, nothing can be seen through it; 50% opacity allows us to see both layers roughly to the same strength. At 0% opacity the top layer is not visible: we can see the bottom layer without obstruction. The strength of each layer can be adjusted and when working with a pile of layers (30 or more is not unusual) controlling opacity and the strength of layer interactions are essential.

Working with layers

Not all image manipulation applications support layers. While software differ in details, the techniques for working with layers are broadly the same. In addition to being able to vary opacity, layers can be turned on or off (made visible or invisible), usually by clicking an icon or choosing a menu option.

You will also be able to move layers around; to shuffle their order: either by clicking an option to promote or demote, or by clicking and dragging with a mouse. The basic image lies on the background: if you wish to move this, it must be turned into a layer first. Each layer can be set to a different blend mode – this multiplies the effects with which you can work. Finally,

SKY
Blends often work best where you have an image with strong lines or shapes – such as the famous ironwork of York station in England – and a blend layer offering broad washes of colour – such as this typically restless sky in Yorkshire – with little detail which might interfere with the lines of the other layer.

STATION

BLEND MODES
The blend modes are broadly divided into groups: those which darken; those which lighten overall; those which imitate photographic combinations such as double-exposure; the blends based on complicated calculations; and blends according to colour characteristics.

STATION NORMAL AT 50%
A normal blend is simply to place one image on top of the other. If the opacity is set to 100%, you see only the top image. At a setting of 50%, each layer is seen roughly at equal strength.

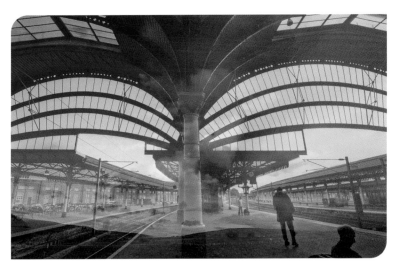

STATION NORMAL AT 50%

when you have arrived at the image you want, all the layers will need to be flattened (turned into a single background layer) for printing or other output.

The cel metaphor

The inspiration for layer interactions came from animated films. Originally, these were created by painting a background, then adding a transparent layer or cel on which were painted some trees, for example, then another layer over these, which carried the painting of a deer. Changes such as movement or different shading in the top layer appeared against the lower layers. In digital imaging, we have a background layer over which we can add layers containing other images.

The interaction between layers – also called blend modes – now depends on what has been programmed in. A simple interaction ensures that the colours in the top layer tint those below, without changing darkness or lightness.

Experiment and play

The best way to understand layer interactions is the same as for filters: try them out with different images, play with the effects and you will soon be revelling in the powers they give you. Some of the most frequently used blends or most dramatic interactions are shown here.

STATION DARKEN
With the blend mode set to Darken, the result is that wherever the top layer is darker than the corresponding pixel on the lower, the top layer's value will be used. This mode gives colour to light areas in the lower layer.

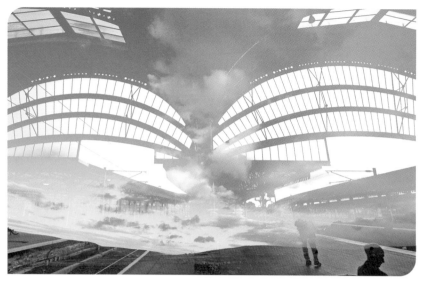

STATION LIGHTEN

The Lighten blend mode is the opposite of Darken, but the visual effect is somehow more than merely opposite: it feels and looks totally different, revealing relationships in tone which were not obvious just by looking at the originals.

STATION DIFFERENCE

By far the most dramatic blend mode, Difference swaps values where the top and bottom layer differ, and also reverses the colours. Such is its drama, it has saved many a digital photographer struggling for inspiration.

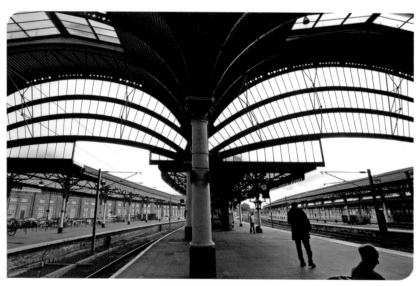

STATION COLOR

A blend mode much used by those who wish to add delicate colour tints to black-and-white photographs: Color mode adds colour to neutral areas without changing their tones, and combines colours where the underlying pixel is coloured.

STATION HARD LIGHT
Some blend modes are related to others: Hard Light is a high-contrast version of Soft Light, and is also similar to Lighten at high contrasts and deeper saturation.

Layer modes for tonal control

SKY MULTIPLY
The Multiply mode offers a very powerful way to spice up the colour and contrast of an image, particularly if there has been an exposure error. Other powerful modes are the various Burn, Dodge, and Light blends. The tweaking of opacity level gives very good control over the strength of the effect.

The majority of the blending modes are directional: that is, the blend applies an effect based on the underlying pixels. As a result, even if identical images are placed together, some blend modes will change the resulting image. However, since there can be no interaction of detail if they share the same features, the change will be entirely tonal or in colour. This gives a powerful and quick way to make dramatic changes to the image, while retaining image quality better than other methods. It is worth remembering this little trick when faced with an image that is badly over- or underexposed.

Cutting and pasting

Gross interactions between layers (those which involve the entire image) are only the beginning. The next stage in our growing ability to work with images comes from being able to combine parts of different images. The basis for this is the ability to lift off the parts we want, leaving the rest behind.

Selecting

Selecting parts of the image in preparation for copying and moving them to another is essentially the same process as selecting pixels in order to limit the application of an effect or tool. But the way we control the selection may be different. If you wish to pick off an object from its background, you have to select it with great precision, lest you leave bits behind or pick up flakes from the background.

We have met the Lasso tool: this selects an area as you draw it freehand: if you do not join up the end of the line with the beginning, the software will automatically join them with a straight between the beginning and the end of the line.

LASSO ERROR
It is all too easy to make a mistake when drawing selections. A mouse with a roller-ball is the most difficult to use for this job; replace it with an optical mouse (uses an infrared light) if you can. And take care: one click in the wrong place and your selection will disappear.

LASSO ERROR CORRECTED
Use modifier keys to help you refine the selection: in Photoshop Elements, you hold down the Shift key in order to extend a selection, and hold the Option (Alt) key in order to reduce or cut into a selection.

BABY ORIGINAL
This portrait of a young baby is cute enough by itself, but perhaps we want a plainer background. We need to select the baby to paste onto another background; alternatively, we select the background prior to deleting it.

Another type of Lasso tool draws straight lines, and as you click on the line, it changes direction. The method with the most promise is the Magnetic Lasso which locates the boundary for you by searching for sharp differences in neighbouring pixels. It can be tricky to use, however, and is not available in all software. A further type of selection tool is the Marquee, which selects a rectangular or circular area.

The commonest mistake made by beginners in digital imaging is to work too quickly. The second commonest problem is to work at a magnification which enables the whole object to be seen, but which means that details cannot be clearly distinguished. So the best advice is to take your time, and to work at 100% magnification (actual pixels) or larger.

With some objects, you will want to make a clean, sharp selection: bottles, lamps or flowers might come into this category. For others, a blurred or feathered selection (see p122) is more appropriate: portions of a landscape or facial features, for example. Feathering should be set before you make the selection. The correct feathering amount depends on the image and the size at which you are working: even experienced workers have to try one or two different settings before settling on the best for a given job. Finally, keep in mind that the lasso line (or marching ants) marks the middle of the transition between full and no selection.

LASSO OPTIONS

MARQUEE OPTIONS
The options bar for the Lasso or Marquee show that you can set the level of Feathering, as well as different ways of interacting with selected areas. Choosing Anti-alias means that you smooth the selection boundary.

FEATHER OPTIONS
This pair of images shows the difference between an unfeathered selection with its crisp, sharp boundaries and a highly feathered one.

Notice how, although both were set to the same nominal radius, the feathered selection appears much larger. The reason for this is that the feathering extends beyond the selection margin. Feathering has also changed the tone within the selection.

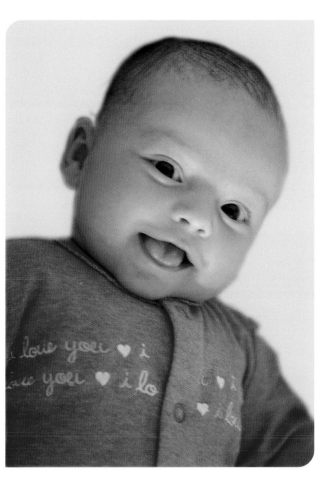

BABY BACKGROUND OFF
The selection complete, if we had selected the background, we can delete it. Or if we had selected the baby we can copy it to another background – here chosen to be off-white to take some greetings. Alternatively you can invert your selection: select instead that which was excluded by your selection, using the menu option or key-stroke appropriate to your software.

Compositing

Once you have made your selection, the software has to load the information into the computer's memory before it can paste or move it into another image. You can copy the information, which leaves the original image intact, or you can cut it – which removes the pixels. The information is held in memory until another selection is copied or cut – a big selection, which sits there long after it has been used, can slow down the software. To avoid this, copy a tiny selection after you have performed the paste: not for use, but to replace the big selection and thus reduce the memory used.

Digital photo-montage

In some photo-montages the elements are not obvious – they are apparent only on close inspection. In others, the elements had been played with irreverently and iconoclastically. In this worked example, simple elements were brought together as a test image for a series on a young woman, photographed in Croatia, working through questions about her identity and place in the world. The vaulting architecture of a railway station is meant to suggest a journey to somewhere unknown, at the same time its vortex-like movement suggests confusion – the woman is just a small, confused element.

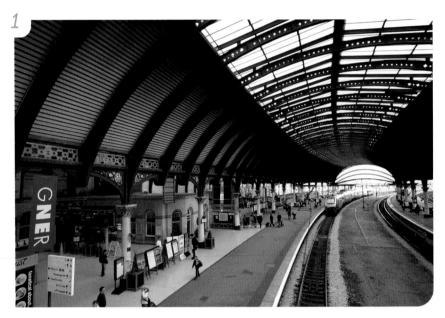

1

STATION
The image of a railway station was chosen for its graphic qualities and simple lines as much as for its meaning.

2

STATION TRANSFORM
The roof and its strongly rhythmic patterns was selected, then rotated using the Free Transform tool. It was then copied ready to be pasted into the other railway picture.

TRANSFORM MENU

3

COMBINED IMAGE
Elements which are pasted in usually go to the centre of the receiving image, by default. So you need the move tool to position the pasted-in element.

LAYERS PALETTE
The Layers palette keeps you informed about which layer you are working in.

4

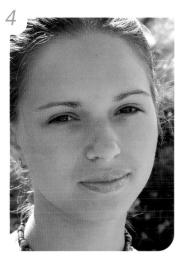

GIRL
An oval marquee is drawn over the girl's face to select it.

5

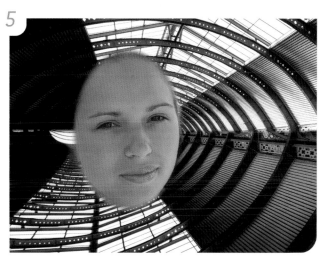

STATION TRANSFORM COMBINED WITH GIRL
Pasted in, the girl's position, the tones and colours of the skin now all need to be adjusted for overall balance.

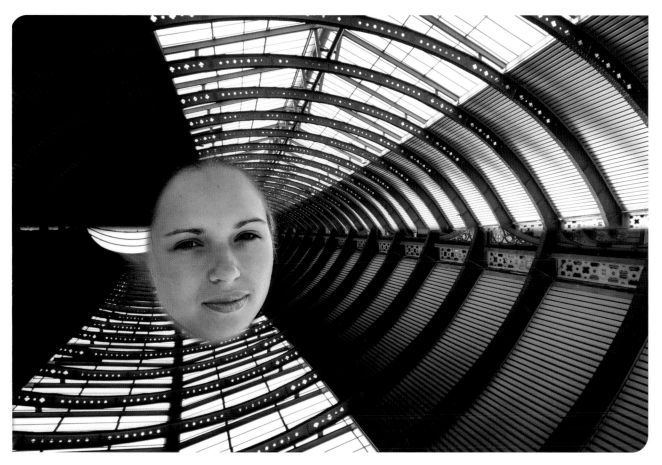

FINAL
The result of the adjustments is a picture that shows promise. Perhaps the face should be rotated, perhaps the background architecture should be made to blur towards the distance, and perhaps some motion blur could be introduced in the background. Or perhaps we just try another idea.

Making panoramas

True panoramas are views that are wider than your eyes can take in at one time, so that you have to turn your head to take them in fully. Alternatively you may have to lift your head or look down if you are at the top of a gorge – in order to take in a panorama that stretches from the sky to the river running far below. Formerly, panoramic photography was a preserve of the privileged few who could afford complicated panoramic cameras. Now, everybody can do it.

Shooting level

Much of the work of making panoramic views is in the original shots. Get these right, and the software will have an easy time of it. It is best to set a zoom length that is around mid-way of the range: lens distortions are usually lowest at this setting. Overlap the shots generously, as you pan from one side to another. Make sure that you pan horizontally: ideally you would use a tripod, but it is possible to get away without. Try to turn the camera around its own centre, rather than around your body's centre, that is, rotate the camera as if it were on a tripod, not simply by turning your head and carrying the camera with it. Finally, and if possible, set the camera exposure to manual: take a reading for the middle of the scene, and use that setting for every shot.

DSCFO799.JPG DSCFO800.JPG DSCFO801.JPG DSCFO802.JPG DSCFO803.JPG DSCFO804.JPG DSCFO805.JPG DSCFO806.JPG

SHOTS
For this series, a different kind of panorama was shot: on a boat trip off the coast of Croatia, I held the camera steady and made shots as the boat sailed past a small harbour. Note that the shots were oriented to portrait format (upright) in order to frame a good portion of sky and sea.

Stitching

When you are back at the computer, you unload the images and start up the Photomerge feature in Photoshop Elements, or use the free software often bundled with digital cameras. The software previews the result of the stitching, which you save if you like it.

Note that as you will be joining up several images, the resulting file can be very large – perhaps more than your computer can comfortably handle. If you find that a problem, reduce the size of the shots before importing them into the stitching software.

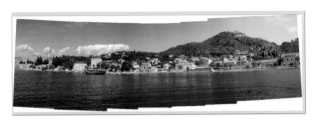

PHOTOSTITCH
Once the shots are imported, they can be processed or stitched by the software: this looks for similarities and differences at the overlapping edges of images and tries to reduce the differences. This shows a preview of the panorama in Canon Photostitcher.

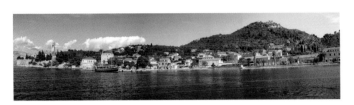

PHOTOSTITCH DONE
The preview image from Photostitcher is cropped to remove the untidy margins of the image and rendered (developed to full resolution). The resulting image is not perfect, but is superior to a single shot.

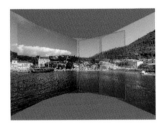

SHOTS IN STITCHER PLUS SHOTS FOR PANORAMA
In the Realviz Stitcher program, which is good for making virtual reality movies in which the viewer can move around the image, matching is done by hand. As your shots are placed, the other display maps the relationship between them.

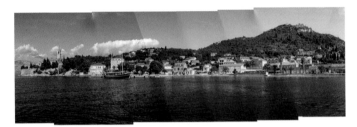

PHOTOMERGE DONE
This version from Photomerge in Photoshop Elements compares poorly with the Photostitch image, but it usefully shows how software applications differ in their handling of identical material. Photomerge also took three times longer than Photostitch to process the images.

PANORAMA
PAS DE CALAIS
You can make a panorama of a very distant scene too: here my telephoto lens was set to its maximum (35efl of 560mm) to convey the undulating flatness of Northern France.

PRINTING
digital images

Preparing the image

Even if you intend placing images on the web for all to enjoy, there will be occasions when you will want to have a physical, touchable print in your hand. Not least because you do not have to boot up a computer to view it, whereas you can tuck a print into your wallet – kissing the image of a loved one is somehow not the same on an electronic screen.

Print accuracy

Making your own prints will offer more satisfaction, but there could be a deal of frustration before the happy outcomes (see pp148–9 for how to reduce the problems). Nonetheless, modern printers do a very good job straight out of the box.

A common error is to assess the print by placing it next to the monitor image to compare them. Only professionals working to the tightest controls need to do that, and truly only the best of them can really match print to screen image. Besides, no-one looks at a print that way. Someone examining your print could be a continent away, under a different sky, with different coloured walls and lights. The issue is whether the print is pleasing. As with any image, we perceive its tone and contrast, its sharpness, overall colour and their relative strengths: if they fall within broad limits and are appropriate to the subject, we tick the 'OK' box and enjoy the picture.

The moral is to not get too hung up on matching the print to the screen image. The reason why we calibrate the screen is to give us a good idea of what the print will look like; we do not need a precise representation.

Pre-flighting

Follow a simple procedure every time you print and you will avoid another common error: an image that is the wrong size. It can be handy to write out a little list of the paper sizes you use and the corresponding average image size, which gives an adequate margin, and stick that near the computer.

The procedure, with the image open in your image manipulation software, is first to confirm that the file is big enough for the size you want to print. Open the Image Size control and check that the output size is correct and, in the output resolution box, that the figure is anything between 120 and 300. With resolutions lower than 120 pixels per inch the image will start to break up into separate pixels, and resolutions higher than 300 are not necessary. This supports the check you made right at the beginning (see p99). Next find Page Setup and choose the paper size and its orientation. Then preview the print: all software offer this facility in one form or another: ensure that the picture is the right way round and fits into your chosen paper size. If it's not right, then resize the print.

Printer and output resolution

Today's printers can place many thousands of dots of ink per inch of print. However, the output resolution you set need not exceed 300 dots per inch (often expressed as pixels per inch). Do not make the error of thinking that to obtain the best quality, you need to match the printer resolution of, for instance, 4800 dots per inch, with an equal image resolution. The file will be impossibly and unnecessarily enormous.

SIZE AND ORIENTATION

Choose your paper size and which way round it should be. Printers are less likely to jam when printing paper lengthways, but that can take longer.

SMALL SIZE BIG PRINT

A small image – only 1000 pixels wide – can print to a large size if a very low resolution is acceptable: here it is 72 pixels per inch, the usual size as recorded by digital cameras. See side-bar opposite.

TOO LARGE

Use the print preview: a small file can still print too large if the output resolution is set too low.

TOO SMALL

A picture that is too small for the paper is not such a disaster as an image that is too large, and therefore becomes cropped. But if you do not really need the broad border, you waste paper.

WRONG ORIENTATION

Printing the image the wrong way round – a landscape view (horizontal format) on portrait view (vertical format) and vice versa – is not a disaster, but either wastes paper or produces an awkward shape.

Printing options

Since the early days of digital imaging, the options for making prints have not only multiplied, but the quality available has improved by enormous leaps. At the same time, costs have come down, ironically, as a result of the industry working out how to harness the economies of working with traditional chemical-based processes in the currency of digital files.

Photographic digital prints

One key improvement is that, in most cities around the world, you do not even need your own computer or printer. All you need is to find a laboratory or store that can print direct from your memory card or CD. Some even have a self-serve facility: pop your memory card into the machine and follow instructions. In a short time, prints of your files will be delivered to you. And, importantly, those prints will be made on photographic paper – so they look and feel very much like prints from film. In fact, results can be such that only experts would be able to tell them apart.

BLUE BOATS
Images with strong and highly dominating colours, such as these blue fishing boats of Essaouria, Morocco, will obviously run through a lot of blue or cyan ink. If ink is supplied on composite cartridges, you may have to buy a new one when the cyan runs out, thus wasting the still ample supplies of red and yellow.

A balanced diet

Of the two types of printer – dye-sublimation and ink-jet – the latter is by far the most widely used. Not only can they be bought at very low prices, they are not too fussy about the material you feed them (some will print onto CD or DVDs) and you can reduce running costs by purchasing third-party or compatible inks, although this may reduce print quality (see also pp148–9).

Most printers use ink cartridges in which three or more inks – e.g. cyan, magenta, yellow – are combined into one composite cartridge unit, with a separate black-ink unit. This is of no advantage to the digital imager. If you print out lots of sunsets you could run out of magenta and yellow inks while the cyan is still nearly full – you would then have to throw away the cyan. If you have a printer using composite units, it makes sense to feed the printer a balanced diet of images if possible: sunsets followed by blue skies, and so on.

Paper choice

One of the critical controls you have overprint quality is the paper you choose. Operationally it is simplicity itself: buy a paper or sampler of papers and make some prints. Stick with the type that gives the results you like best. Of course, this 'dating' process can be quite costly, unless you fall in love with a paper soon after you start looking. However, there is no such thing as a perfect paper, and certainly not one that is perfect for every image. You settle on a sleek, glossy stock that is perfect for brilliant, brightly coloured images of urban graphics, but when you print a portrait shot in black-and-white, the paper is inimical to the image's mood. In short, you may have to use different papers to match the image, the occasion (wedding gift, proof print) and even the size: papers with a texture such as canvas are often unsuccessful when printed small.

SKY TOWER
The light of a sunny day in New Zealand delivers sharply defined, very high-contrast images. There is no need to print it on glossy paper for its effect to be clear: in fact, too high a gloss would make the image too hard and visually brittle. A semi matt-surfaced paper is ideal.

DUBROV TWILIGHT
The limited tonal range of this image makes it a good candidate for a gloss-surfaced paper. This would help give a good density of black, which gives a visual foundation to make the best of the limited contrast.

Computerless printing

The problem with any system that prints out without the aid of the computer is to see what you are doing. Without the computer you have a choice: either preview the image on the camera's screen (where you may be able to 'order' prints through menu options) or preview the image on the printer's screen. Both, on current machines, are very small but we can expect to see larger screens on a new generation of printers. Self-contained printers also use quite sophisticated image analysis programmes that automatically assess an image and correct it, matching the corrections to the paper and inks being used. The results are really very good, and steadily improving.

Using pictures as graphics

We have progressed steadily and rapidly from requiring formal letters to be typewritten, to being word-processed, to the need to be design-aware. And, now, it is becoming *de rigueur* to incorporate images or graphics, certainly for business communication in which the purpose is to impress, sell or promote.

BUSINESS CARD
Suppose you want to promote a change of career – to be a landscape gardener, for instance – you may want to add a garden motif to your business card. A simple design repeated onto perforated card (or plain card trimmed) to provide business cards cheaply and conveniently – without having to order hundreds which you will never get through.

Clip-art or your art

Now that you are mastering digital imaging, there is no need to rely on clip-art – the graphic equivalent of fast food: ready-made images lacking in substance. But it is useful to browse through collections that come with your word processor software to see what professionals produce, and see how to improve on them. If you want smiley faces, why not photograph some friends with different expressions, then adapt them for your own collection of clip-art. Or if you like to scatter flowers over your newsletters, you can create a collection symbolizing different types of news that you feature.

Clip-art also teaches you how much can be shown or said in a very small image indeed. You need only keep the message clear, and stick to one subject.

GARDEN CENTRE
This shot of a garden shed promised to yield a suitable motif for the business card. Almost any small extract of the Japanese Maple leaf has the capacity to deliver a usable graphic.

LOGO
A small section of leaves near the middle of the picture was selected, copied and pasted into a new image file and sized to the actual dimensions at which it would be used – just 2cm (¾ in) wide. It was then manipulated to make it more graphic with brightened and deepened colours and increased contrast. You could have used clip-art, but this is so much more rewarding.

Promotion or selling

You do not have to be in business to find yourself trying to sell something, or needing to promote a cause or yourself. You may want to move house, clear out that garage at last, or help raise funds to protect a local amenity like an old persons' day centre. If you want to reach people, it is hard to think of an effective way that does not use images in one form or another. And there is no one better to provide the images than yourself. On the spot, with the requisite skills – you need only turn on your computer – and it is likely you already possess the software needed to prepare the material.

Start by planning what you want to show and say. Draw a simple sketch of what your leaflet or booklet will look like. From this you can work out the size of the pictures you need. Select simple, clear images for your literature. Resize the image files to just a little larger than the size you need – to allow for a change of mind – and set a resolution of around 200 pixels per inch.

For business cards too, you can add a little design or image to distinguish yourself from everyone else. Use the 'wizards' in word-processor software to help you create a grid of identical cards which can be printed out onto A4 sheet of perforated paper. After printing, all you need to do is to tear off the individual business cards.

HOUSE FOR SALE
If you want to sell, let or exchange your house, you are the person who can depict it at its best: you know when the best light is and you can easily spend the time needed to make an appealing shot. If you were to hire a professional, you could expect no more than the best possible for the time and lighting available on the appointed day – too bad if it's rainy.

CLIP-ART
A collection of clip-art, selected from the Microsoft Office collection, showing the range of images: wide in graphic approach, but shallow in artistic depth.

Fun with design

One of the revolutionary aspects of digital imaging easily passes notice. For most of the history of the image, and almost all of history, we deal with the picture in its entirety and the entirety of the final item lies within the picture frame. With web pages we have started to loosen ourselves from the shackles of the picture frame. Now we discover the freedom of the open spaces of a page. It is a thrilling moment when you realize that a picture is more when it is less: that is when it works in partnership with space and other pictures.

CARD GREETING AND CARD FOR TEXTBLACK
You can add text to your card using the Text tool in image manipulation software. Remember to keep the wording large and clear.

CARD RESIZE CANVAS
One simple way to set the card size is to create the picture first, then double its width using the Canvas Resize control. At the same time, you can give the new page a tint to make it more attractive than plain white.

Greeting cards

Since modern ink-jet printers can take quite thick material, you can make your own greeting, congratulation or thank-you cards. In your choice of card, check that the reverse side is not overprinted very lightly with the manufacturer's name, which is done to help you identify the printing side. Either buy double-sided paper (if you plan to print on both sides of the card), or buy one-sided paper without the overprint and follow the indications on the pack to ensure that you print on the right side. Cards are easiest to produce if you have a printer that will print 'to bleed' (make borderless prints) – this saves on trimming the card afterwards.

Start by deciding on the size of card, then remember that your image sits on the right-hand side when you print it (assuming you read front-to-back). Before you fold the card, score along the fold-line on the inside, that is, run a blunt edge like a fish-knife down the line. This prevents the card from buckling.

Library of letterheads

The simplest, useful design exercise is a letterhead. But you can go much further. You can create a range of related letterheads. In the example shown here, we have simply added four different pictures on separate layers: we can turn these on or off as we wish, thus printing whichever version we like. In addition, one of the layers adds a very pale tint to the paper for variety. You can print out a batch of, say, ten prints on your ink-jet printer from your image manipulation software. Then run them through again when you write your letter, taking care to line up address and text to avoid the images. Images in your letters make a very strong impression – the kind of feature that distinguishes your covering letter to a job application from hundreds of others. It is also a stylish way to adorn your letters.

LETTERHEAD ALL LAYERS

This shows all the elements if they were to be used at once: not much space for the letter, but of course you would not turn all the layers on at once. In the Layers Palette you can click on the eye icon on the left to turn off a layer.

LETTERHEAD VERTICAL STRIP LETTERHEAD VERTICAL STRIP

LETTERHEAD HORSE – OFFWHITE

In this variant, the paper-white has been replaced by a very light tint over the whole paper. As this can take up quite a bit of ink despite the weak colour, it is preferable to used tinted paper, but the option can be handy.

LETTERHEAD WITH TWO HORIZONTALS

By turning one or more layers off, you are effectively choosing from a whole library of templates: you can add more layers as inspiration takes you. Each element was selected from an original image, then pasted into the letterhead document. It was then resized and positioned.

LETTERHEAD ALL COMBINED

Best printing

There are two aspects to getting the best results from your printer. The first, obvious, requirement is beautiful prints with accurate colours. The other is efficiency: running a printer can be a costly exercise, both in terms of time and materials.

Ink and paper

The key factor for print quality is the teamwork between ink and paper. You can be sure that a good paper will give a better result than an inferior grade of paper. Certainly, the quality of paper sets the upper limit of what a printer can do. Glossy papers give the most vibrant and richest colours, with good contrast thanks to the ability to take a solid black. But the impression can be shiny and mechanical. At the other extreme, is matt-surfaced paper: not being shiny, it is easier on the eyes. However, it tends to dull colours and flatten contrast. For the best results, it is generally worth paying more. The printer manufacturer's own inks are usually superior to cheap substitutes. However, some independent inks are costlier than manufacturer's inks, but produce the superior results required for photographic purposes.

RED ROCKS
Images like this are tough to print: you need the finest print resolution to define the details of the trees; and very even printing to obtain a perfectly even sky. For best results, set the highest resolution, and the best quality (rather than speediest) printing. And use the best paper you can afford.

Printing efficiently

Picture packaging is the process of cramming as much onto your paper as you can, in order to maximize printing time and paper resources. You may want to make two small prints, but have only large paper. Or you want to make several small prints to give away. Rather than make separate prints with different sized papers, picture-packaging software or facilities in image manipulation software can arrange all that for you.

PIC PACKAGE MENU
In Photoshop Elements, picture packaging is found at the bottom of the File menu.

PICTURE PACKAGED
The simplest option is to place the same image onto the paper – the same size or a variety of sizes, all designed to make maximum use of the paper for the image proportions you have.

Reduce black output

A common problem with ink-jet printing is delivering too heavy a load of ink onto the paper. This is more serious when using cheaper and lighter-weight papers: too much ink from printing dark colours causes the paper to buckle or, in bad cases, become sodden with ink. At any rate, placing more ink on the paper than is needed for the print is a waste, and a costly one at that. A simple solution is to reduce the Black Output level by a very small amount: the difference would be almost invisible to the eye, but save substantially on ink.

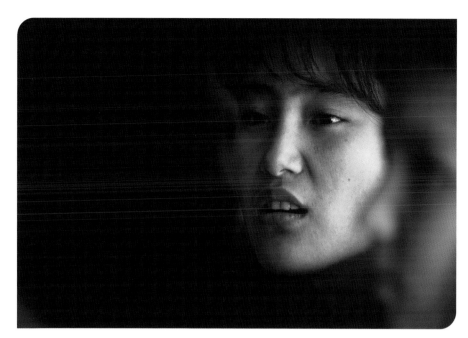

KYRGYZ GIRL UNDEREXPOSED
The heavy dark areas are a great counterpoint to the soft light on this young Kyrgyz woman, but it will print heavily with contributions from all inks in plenty.

KYRGYZ GIRL LEVELS
The Output Black control is at the bottom left of the Levels control in Photoshop Elements. Increase it from 0 to about 4 or 5 so that the maximum density of ink is reduced. Essentially, this sets the highest ink loading: it saves on ink, and you can hardly see the difference.

DIFFERENT PICTURES PACKAGED
You can place different images onto the picture package: click on the placeholder in the preview, and you will be asked to nominate another image. When you do so, the software will open it and automatically size it to make the best fit in the available space.

Such is the pace of modern technology that it took ink-jet printing less than 10 years to leap from under-dog of print-keeping qualities (prints would fade almost before your eyes) to king-pin. Now, prints from even mid-range printers can rival, and even surpass, the keeping qualities of photographic colour prints. For best results, prints should be kept out of direct sunlight and ultraviolet (UV) light, free from humidity, and protected – preferably under UV-absorbing glass. Prints can be sprayed with UV-protecting varnishes.

Pictures for other uses

It is clear that digital imaging has opened out the uses of photography from the basic display and sharing of prints – passing them between friends and family, pasting them in an album – to sharing them on the World Wide Web. We have seen how pictures can so effectively lift the game even of your letter-writing. Now we look at how pictures can lift your public speaking or group or office presentation well above the ordinary.

Making presentations

While few of us have the gift of oratory, we all need to explain ideas to small or large groups, even make speeches to the public from time to time. Just as hand-bills and flyers are expected, in industrialized communities, to be designed and carefully printed, it is rapidly becoming the norm to illustrate any talk or verbal presentation. Your skills in digital imaging put you at great advantage to those who have none. Suppose you have to explain the work of a strategic planning group for a housing association, or want to raise awareness and funds for a child education trust. Perhaps a local nature reserve is under threat from a nearby school which puts on regular firework displays. Your message will, without question, benefit from the apt and targeted use of images – and the better they are, the more effective will your message be.

VERTICAL
A small section of a talk on the gardens of Holland Park, London may show these flower-beds. The series is coherent not only because the subject-matter is related, but the size and orientation of each image is the same, making it comfortable to view.

VERTICAL, HORIZONTAL, VERTICAL
In this series, the middle – horizontal or landscape format – image is superior to its vertical format image in the other series. But the changes in orientation from horizontal to vertical and back again in this series is disorienting for viewers.

Showing options

The technically easiest way to show images is with an overhead projector: a normal page-sized transparency is projected onto a wall using a bright light shining through the transparency onto a projection lens via a mirror. You can print images onto transparent film: you may need to make the images very strongly coloured and much darker than when printing to paper. Ensure you use transparent film recommended by the printer manufacturer or the ink will never dry. If you have a laptop computer, the easiest presentation is to use the computer – your images are probably already on it. Unfortunately, even with the largest screens you can reach only a very small group of

people. But, since they must see the screen with you, it makes for a cosy presentation. Modern offices are increasingly equipping themselves with data projectors that communicate with a computer to project the display onto a wall. You have the option of presenting a simple slide show that changes on mouse clicks, or runs automatically at intervals of a few seconds. You can also create a more sophisticated presentation using software such as Microsoft Power-Point or Apple Keynote to combine text with pictures and transition effects.

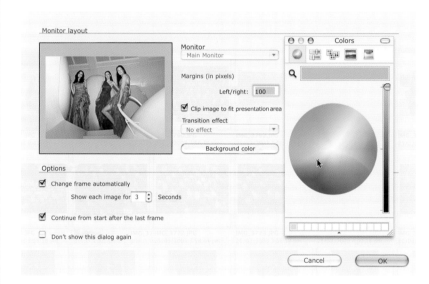

SLIDE SHOW OPTIONS
The slide show generator in Fotoware Fotostation allows you to choose a background colour, some basic transitions in addition to the usual choice of automatic timing or slide-change on mouse-click.

SLIDE SORTER VIEW
In Microsoft PowerPoint, you can sort the order of slides manually by clicking on an image and dragging it into position. An overview such as this is essential for organizing a large show of images, but beware that the resulting file will be very large: this one measures 127MB.

Preparing presentations

The principles for preparing your images for web use (see p90) or printing out (see p148) apply equally to presentations. A little planning saves a lot of time. Once you have selected your images and their running order, you may need to rename them so that they run in that order, since some software will show images only in the order it finds them in the alphanumeric listing. A good time to rename them is when you resize them to fit the screen: 640 x 480 pixels fits the majority of screens, but for high quality size them to 1280 x 960 pixels. At the same time, you may need to make your images a little more contrasty and richer in colour than for normal viewing: the room in which your presentation takes place is unlikely to be very dark, and the projector may not project a top-quality image. Unfortunately it is easy to over-correct your images. Experienced presenters make two sets of images: one normal, for good conditions; the other with enhanced colour and contrast, for poorer projection conditions. Trial run the presentation to ensure that the pictures look fine and are at the right size.

You may be able to save your slide shows in a form that can be copied onto disc (they are usually too large to be emailed). In Photoshop Elements, you can create a PDF (Portable Document Format) slide show which can be read by Acrobat Reader – which anyone who browses the web will have. PowerPoint shows can also be saved as stand-alone 'movies'. Beware that these files can grow very large without much inducement.

Glossary

ANALOGUE Effect, representation or record that is proportionate to some other physical property or change.

ANTI-ALIASING Smoothing away the stair-stepping in an image or computer typesetting.

ATTACHMENT File that is sent along with an email e.g. image.

BACKGROUND Bottom layer of an image; the base.

BACK-UP Make and store second or further copies of computer files.

BLACK An area that has no colour due to absorption of most or all light.

BLEED (1) Photograph or line that runs off the page when printed. (2) Spread of ink into fibres of support material: the effect causes dot gain.

BMP Bit Map: file format native to Windows.

BRIGHTNESS Quality of visual perception that varies with amount or intensity of light.

BROWSE To look through collection of e.g. images or web pages.

BRUSH Image editing tool used to apply effects such as colour, blurring, burn, dodge, etc.

BURNING-IN Digital image-manipulation technique that mimics darkroom burning-in.

BYTE A word or unit of digital information.

CYAN A secondary colour made by combining two primary colours, red and blue.

CALIBRATION: Process of matching characteristics or behaviour of a device to a standard.

CHANNEL Set of data used by image manipulation software to define colour or mask.

CMYK Cyan Magenta Yellow Key: the colours of ink used to create a sense of colour.

CLONE To copy part of an image onto another part or onto another image.

COLOUR MANAGEMENT Process of controlling the output of all devices in a production chain.

COMPOSITING Picture processing technique that combines one or more images with a basic image.

COMPRESSION Process of reducing the size of digital files by changing the way the data is coded.

CONTRAST Measure of subject brightness range.

DELETE To remove an item from an image or a file from the current directory.

DEPTH OF FIELD Distance in front of and behind the plane of best focus over which any object in front of the lens will appear acceptably sharp.

DISPLAY Device that provides temporary visual representation of data, e.g. monitor screen, LCD projector, information panel on camera, etc.

DODGING Technique for controlling local contrast during printing by selectively reducing the amount of light reaching parts of print which would otherwise print too dark, and its digital equivalent.

DPI (dots per inch) Measure of resolution of output device.

DRIVER Software used by computer to control or drive a peripheral device such as scanner, printer, or removable media drive.

DYE SUBLIMATION Printer technology based on rapid heating of dry colorants held in close contact with a receiving layer.

ELECTRONIC VIEWFINDER (EVF) An LCD screen that shows the view through the camera lens.

EXPOSURE Process of allowing light to reach light-sensitive material to create the image.

FEATHERING Blurring a border or bounding line by reducing the sharpness or suddenness of the change.

FILE FORMAT Specific way that computer data is organized.

FILL To cover an area with colour – with the Bucket tool.

FIREWIRE Standard for rapid communication between computers and devices.

FLATTEN To combine multiple layers and other elements into a background layer.

FONT Computer file describing a set of letter forms for display on screen or to be printed.

GAMMA In monitors, a measure of the correction to the colour signal prior to its projection on screen; a high gamma gives a darker overall screen image.

GIF Graphic Interchange Format: a compressed file format designed to use over the Internet.

HISTOGRAM Graphic representation showing the relative numbers of something over a range of values.

HOT-PLUGGABLE Connector or interface which can be disconnected or connected while computer and machine are powered e.g. USB and FireWire.

IEEE 1394 Standard providing for rapid communication between computers and devices. (See also FireWire.)

INK-JET Printing based on squirting extremely tiny drops of ink onto a receiving substrate.

INTERPOLATION Inserting pixels into an existing digital image based on existing data.

LAYER MODE Picture processing or image manipulation technique that determines the way that a layer in a multi-layer image combines or interacts with the layer below.

LCD Liquid crystal display: type of display using materials which can block light.

LOSSLESS COMPRESSION Computing routine that reduces the size of a digital file without reducing the information in the file e.g. LZW (named after its developers, Lempel, Ziv and Welch).

LOSSY COMPRESSION Computing routine that reduces the size of a digital file, but also loses information or data e.g. JPEG.

LPI (lines per inch) Measure of resolution or fineness of photo-mechanical reproduction.

MARQUEE Selection tool used in image manipulation and graphics software.

MEGAPIXEL Million pixels: used to describe class of digital camera in terms of sensor resolutions.

NOISE Irregularities in an image which reduce information content.

OPACITY Measure of how much can be 'seen' through a layer.

OPTICAL VIEWFINDER Viewfinder that shows subject through an optical system, rather than via a monitor screen.

OUT-OF-GAMUT Colours from one colour system which cannot be seen or reproduced in another.

PIXEL Picture element: the smallest unit of digital imaging.

PIXELLATED Appearance of a digital image whose individual pixels are discernible.

PLUG-IN Application software that works in conjunction with a host program.

PPI (points per inch) The number of points which are seen or resolved by a scanning device per linear inch.

RGB (Red Green Blue) Colour model that defines colours in terms of relative amounts of red, green and blue components.

THUMBNAIL Small, low-resolution version of an image.

TIFF File format: almost universally recognized.

UPLOAD Transfer of data between computers or from network to computer.

USB (Universal Serial Bus) standard port design for connecting peripheral devices e.g. digital camera, telecommunications equipment, printer, etc. to computer.

USM (UnSharp Mask) Image processing technique that improves apparent sharpness of image.

WRITE To commit data onto a storage medium e.g. CD-R.

Further reading and web resources

Information sources

www.bhphotovideo.com Site for photo-retailer but also one of the comprehensive guides to equipment and accessories – at times superior to manufacturer's own.

www.dpreview.com Up-to-date, exhaustively detailed and informative reviews of digital cameras, also news, discussion fora and good level of information. The site is constantly updated.

www.shutterbug.net Wide-ranging photography resource run by the US magazine Shutterbug.

www.imaging-resource.com Frequently updated reviews of digital cameras.

www.shortcourses.com Very popular site offering on-line features on digital photography and instruction books for digital cameras, with links to other resources.

www.kenrockwell.com Technical tips, pithy reviews and links for digital cameras, scanners, etc.

www.wilhelm-research.com Reports of tests on inks and papers to help judge quality, longevity, etc.

www.inkjetmall.com Resources, techniques and services relating to ink-jet products, particularly for black-and-white printing.

www.wetpixel.com Information for underwater digital photography including specialist equipment, diving updates and portfolios of images.

www.webreference.com/graphics Wide coverage of range of relevant issues from scanning, formats to animation.

www.creativepro.com Provides free on-line version of Extensis Intellihance Pro working through Internet browser to manipulate images to improve overall quality.

www.mazaika.com Photo-mosaic software and library of small images to use.

On-line printing services

www.cartogra.com Prints made on Kodak Professional paper on a site run by Hewlett-Packard. Using Share-to-Web software, you can upload images directly from a HP scanner to this site.

www.easymemories.com Print service and access to online photo-gallery.

www.fotki.com Picture-sharing service and on-line printing.

www.fotango.com Users with their own websites can use script supplied by Fotango to make it easy for visitors to order hard copy prints (on a mouse-mat, mug, etc.) – with printing handled by Fotango.

www.kmobile.com Picture-sharing and support for mobile phone camera users.

Selection of manufacturer and software sites

www.epson.com Helpful technical guides on trouble-shooting your printer and how to get best results.

www.apple.com A good deal of information on this first-class site.

www.adobe.com Superb site with lots of useful material – well worth serious digging around.

www.canon.com Cameras and lenses and accessory system, digital cameras, printers, scanners, etc.

www.fujifilm.com Digital cameras, film cameras, and medium format cameras.

www.kodak.com A site full of resources and many free images to play with.

www.digitalfilm.com Lexar – memory cards and readers for digital cameras.

www.lexmark.com Printers.

www.lemkesoft.de Excellent yet inexpensive software for image conversion and basic manipulations.

www.nikon.com Cameras, lenses, accessory systems, and film-scanners.

www.olympus.com Cameras, lenses, printers, removable storage.

www.pentax.com Cameras and lenses (including medium-format cameras and lenses).

www.ricoh.com Cameras

Further reading

Silver Pixels

Ang, Tom; Argentum; London; 1 902538 04 8

An introduction to the digital darkroom – written for those converting from film-based photography.

Dictionary of Photography & Digital Imaging

Ang, Tom; Argentum; London; 1 902538 13 7

Comprehensive listing of technical terms used in conventional and digital photography.

Digital Photographer's Handbook 2nd edition

Ang, Tom; Dorling Kindersley; London; 0 7566 0346 3

Full coverage of the subject – from choice of equipment and software, through image manipulation and projects to output options. Suitable for those moving on from Digital Imaging Handbook. Also in a compact edition under title *Digital Photography: An Introduction*.

How to Cheat in Photoshop

Caplin, Steve; Focal Press; Oxford; 0 240 51702 4

Brilliant illustrations, step-by-step instructions and packed full of tricks from one of the finest masters of them all.

Photoshop Restoration & Retouching

Eismann, Katrin; QUE; Indianopolis; 0 789 72318 2

Here are 250 pages on retouching techniques: it is thorough, well-illustrated and leaves no brush unturned in its pantheon of advice. Highly recommended.

Digital Printmaking

Whale, George & Barfield, Naren; A&C Black; London; 0 7136 5035 4

Inspiring mix of first-rate work with applications of Photoshop to printmaking techniques.

Complete Guide to Digital Photography

Freeman, Michael; Thames & Hudson; London; 0 500 54246 5

A wide-ranging, if not quite complete, treatment with well-written text and high-quality illustrations lift this one well above its competitors.

Digital Image Creation

Kojima, Hisaka & Igarashi, Takenobu; Peachpit Press; Berkeley; 0201 88660 X

Wide-ranging survey of digital image manipulation.

Index

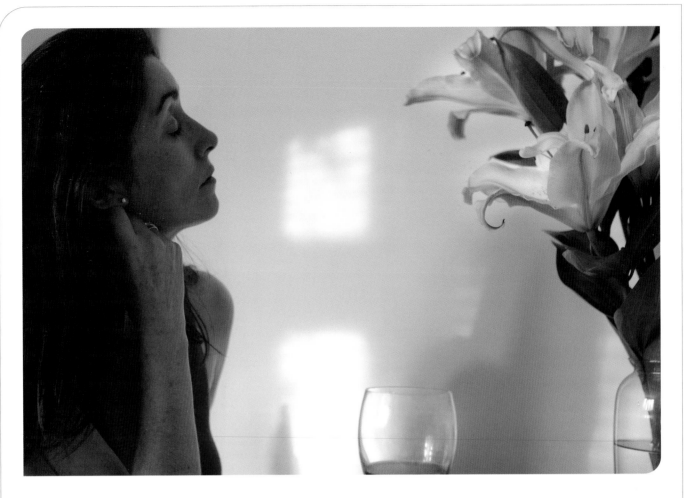

Acknowledgements

I am delighted to give first thanks to my commissioning editor at New Holland, Alfred LeMaitre, who commissioned the book and who proved to be the most helpful and supportive commissioning editor one could wish for.

For technical assistance, I am grateful to Extensis, Fujifilm, TypeMaker, and Adobe. Many thanks to Cicely Ang and Wendy Gray for their photographic contributions and to Cicely for her assiduous picture assistance. As ever, my warmest and heart-glad thanks are for my wife, best friend and partner, Wendy.

Photographic Credits

Copyright © in photographs for those listed below rests with the following photographers and/or their agents:

Cover (centre): **Photo Access**

Cover (front flap-bottom): **Photo Access**

Cover (back flap): **Wendy Gray**

p10 (bottom): **Photo Access**

p73 **Wendy Gray**

p113 (top right): **Cicely Ang**

p118 (bottom left and right): **Cicely Ang**